SCULPTING WITH CEMENT

SCULPTING with CEMENT

DIRECT MODELING IN A PERMANENT MEDIUM

BY LYNN OLSON

PHOTOGRAPHS, DRAWINGS,
SCULPTURES AND DESIGNS BY THE AUTHOR

STEELSTONE

PRESS

Valparaiso, Indiana

Eleventh printing

Published by the

STEELSTONE PRESS
4607 Claussen Lane
Valparaiso, Indiana 46383-1526

(219) 464-1792

Library of Congress Cataloging in Publication Data

Olson, Lynn.
 Sculpting with cement.

 Includes index.
 1. Cement sculpture--Technique. I. Title.
NB1215.047 731.4'2 81-708
ISBN 0-9605678-0-1 AACR2

Printed in the United States of America

Designed by Lynn Olson

DISCLAIMER: This book is intended for use by sculptors, artists, and other persons who will accept full responsibility and liability for the use and applications of all materials and suggestions contained in this book. All information in this book is intended for those who are competent to evaluate the limitations, the possibilities, the capacities and the significance of the information. The author disclaims all responsibility and liability for the application and consequences of the use of any information in this book.

CAUTION: It is intended that anyone using this book will follow all safety precautions suggested for the use of any and all materials and tools and will also follow the safety precautions recommended by the manufacturer of those materials and tools. Do not allow cement, either wet or dry powdered, or unhardened to contact any part of the body. Avoid eye or skin contact with any and all admixtures or polymer emulsions suggested in this book. Always provide adequate protection for the eyes, nose, mouth, lungs and skin. Always provide adequate ventilation in the work area.

ACKNOWLEDGEMENT

 Special thanks to Fred and Lois Carlen
 for bringing out the best in the photographs.

CONTENTS

FRONT COVER: *Continuity III,* linear design in steel, polymer, white cement and carbon fibers which appear as fine lines in the polished surface. Installed at Tower East in Shaker Heights, Ohio.

For Mother, who gave me her esthetic perceptions

I. Why Cement

CAN BE MODELED BY HAND. A cement mixture can be shaped with your hands or with simple modeling tools into any design you wish — without molds.

FLEXIBLE AND VERSATILE. When used as a direct medium in combination with steel, cement provides a freedom that makes any complex form possible. You can model figures or build open web structures or make thin and flowing shell designs. Sculptures as small as jewelry ornaments or as tall as buildings become possible.

UNIQUE AESTHETIC QUALITIES. Cement has long been associated with sand and the coarse, monotonous texture of the sand has dominated the aesthetics. But cement can be used with many different ingredients and each will add its own unique aesthetic qualities. Different fibers, steel wool, bronze wool, glass fibers, polypropylene fibers, polyethylene pulp, aramid pulp, nylon fibers, acrylic fibers and carbon fibers are mixed with cement. Steel or bronze wool or the carbon fibers can add special aesthetic qualities. Carbon fibers in white cement can add an intriguing pattern of fine black lines as in the sculpture on the front cover. Pigments create attractive colors in white cement. Several aggregates can be tool worked or polished in the surface. Particles of elemental silicon add metallic luster and particles of blast furnace slag can be polished to a dark luster. Tool marks add surface texture. A transparent coat of methyl methacrylate adds gloss to further enhance the color and texture.

DURABLE AND PERMANENT. When mixed with a minimum of water and properly cured, cement hardens into a weatherproof compound. Latex polymers increase the durability.

INEXPENSIVE AND AVAILABLE. Cement is the least expensive of the permanent sculptural mediums and is locally available.

OLD AND NEW. Found beneath the ancient city of Jericho and made 9000 years ago in the Neolithic Period are sculptures created by modeling a calcium carbonate cement into human features on human skulls. These direct cement sculptures were made many thousands of years before copper or bronze was cast into artifacts. Today's portland cement—mainly calcium silicate—has long been cast into plaster molds. The limitations of the casting process has prevented the full development of its unique sculptural possibilities. By using it directly—without molds—you can explore its many potentials.

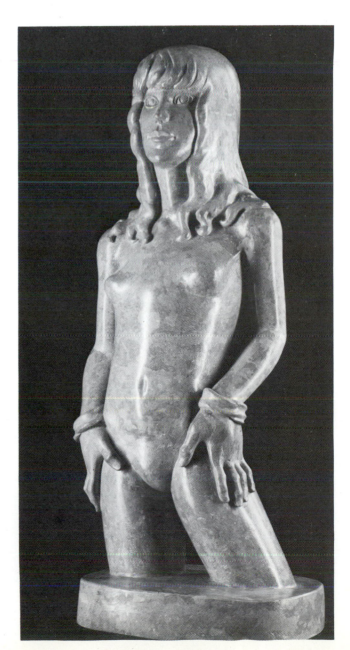

Peggy 32 inches (81 centimeters). This figure was built hollow following the procedure illustrated on pages 58-60. The surface was tool worked with riffler rasps.

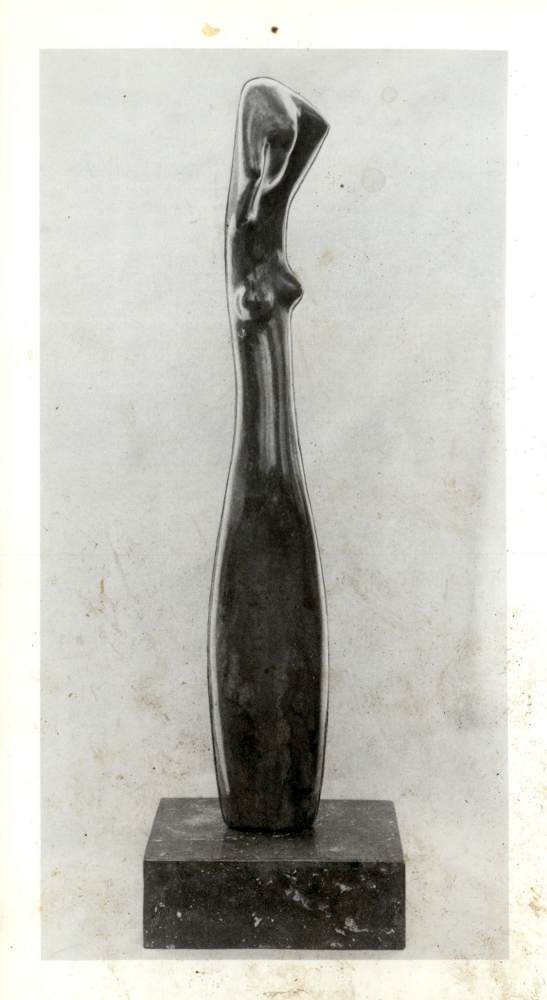

Olive
30 inches
(76 centimeters)

Private collection.

II. How To Get Started

The way to start is to build a small, easy-to-make design.

BASIC TOOLS AND SUPPLIES

Portland cement, either gray or white but preferably white. Not the waterproofed white as it requires an extended mixing time. Type I is the most generally available. Type II is for special purposes and Type III is ground to a finer particle size to develop strength quicker. Types IA, IIA, and IIIA entrain tiny bubbles of air, are known as *air-entraining,* and are not used with polymers (see page 20). Either of these types is suitable.

Cement can be mixed with a minimum of water to make a thick paste, known as *neat cement,* that can be modeled into a shape. But adding thin fibers will produce *fiber-cement* for better self-supporting shapes and more strength. Many different fibers can be used (see page 105) but steel wool is generally available. The medium grade of steel wool may be the easiest to begin with.

Galvanized or bare steel wire is used to reinforce the design and should be soft enough to be easily bent and cut by hand. The 18 to 20 gauge, usually packaged in coils of fifty feet, is easy to handle. The 28 or 32 gauge wire available on small spools is also suitable. Heavier wires, such as the 17 gauge electric fence wire and the nine gauge can be used for larger designs. Bronze, brass or copper wires can be used but, to avoid galvanic corrosion, not in the same design with steel (see page 22). A long nose pliers with side cutter is recommended for cutting and bending the wires.

A large stainless steel kitchen basin is best for mixing and is easy to clean.

Durable rubber gloves that cover the wrists are necessary to protect the hands. Safety goggles to protect the eyes are essential. An eye wash station or eye cup should be available.

An inexpensive kitchen knife with a mild steel blade will allow the pliers to bend the end of the blade to make a tool for applying small amounts of mix. A sharp knife is needed for carving the hardening cement.

A small, inexpensive brush will apply the slurry.

Store the cement sack in a large waste can with lid. Before opening the cement sack place it in a large plastic bag and then slide both into the can. After opening the sack to remove cement close the plastic bag over it to keep out moisture and replace the lid. To control dust keep the cement outside and do the mixing outside.

Unroll the steel wool and pull away a narrow ribbon of the steel fibers. Put on rubber gloves and safety goggles and put a small amount of cement into the mixing basin. Add a little cold water and mix until you have a thin, watery mixture. Push the steel wool fibers into the watery cement mixture so the mixture surrounds each steel fiber. Now add more cement and mix until you produce a thick, pasty mixture of steel wool and cement. If the mixture feels too dry add more water. If it feels too wet add more cement. If the steel fibers form into knots or lumps pull the fibers apart and continue mixing. As the wet cement fills the spaces between the steel fibers you will produce a soft, plastic mixture that begins to resemble the feel of moist modeling clay.

Spread a plastic bag over your work surface. Place the fiber-cement on the plastic and, with your bent-end knife, push it into a simple shape. You might shape a simplified body with a long neck, two legs, two feet and short stumps for arms. The feet will be extra large with the toes up. When finished cover the work loosely by folding the plastic over it and let the cement set overnight.

The next day the fiber-cement figure should be strong enough so you can pick it up. Thoroughly wet your work at this time. Cement needs additional water to continue hardening and should be kept wet after it sets. Turn the figure in your hands and examine if from all directions. Decide where you want to cut away excess material. Decide where you want to add more material.

With your sharp knife cut into the sections you want to remove as if you were whittling wood. When fiber-cement is only one day old it can be carved easily. The next day it will have hardened more and can still be carved but only with more effort. You will soon learn how long to let it harden for the best carving condition. Because of its large feet the figure should stand up by itself. If necessary whittle the bottoms of the feet to flatten them.

Fiber-cement that is only one day old can also break easily so handle it gently. If the work breaks it can be repaired by placing wet cement between the broken surfaces and then adding patches of fresh fiber-cement around the sides of the break and letting it set overnight. You can also modify the shape of your work by deliberately breaking and repairing it. For example, you could change the direction of a leg by breaking it at the hip or knee. Place the leg in its new position, pack fresh fiber-cement between the broken surfaces, and let it set overnight.

After whittling away unwanted material you can add more fiber-cement to develop the design. But first strengthen your work by winding thin wires about it in a helical or spiral manner. Keep the wires snug but loose enough so fresh cement can be pushed under them.

Prepare some *slurry* by mixing cement with water to the consistency of thick paint. Brush this slurry on the work and be sure to push the slurry under all wires and into all crevices. The purpose of the slurry is to provide good contact and adhesion between the already hardened material and the new, fresh mixture.

Prepare more fiber-cement as before and push it against the design where you want to build up the form. Be sure the new mixture is pressed firmly between the wires. Continue adding small amounts of fresh mixture and using the knife with the bent end, block out the facial features, hands and other details in their general form only. Stand the figure on its own feet and widen the feet by packing more fiber-cement about their edges.

Drop a plastic bag over the standing figure and let the cement set overnight. In the morning thoroughly wet the figure and again whittle away excess material, carve grooves where necessary and carve details in the features of the face and hands. If steel fibers pull away from the

cement when carving let the cement harden longer before continuing. If, after carving, some holes need to be filled or sections need to be extended you can add more material. Apply a slurry first to insure good contact and adhesion.

When finished, thoroughly wet the design and wrap it in plastic. Cement hardens slowly by combining with water over a period of several weeks. It needs additional water to completely combine all the cement and develop its full strength so keep the work wet for at least a week and preferably four weeks. Keeping it wet to develop strength is known as *curing*.

You may prefer to build a simple, non-figurative design. One way to start is to drape fiber-cement over an irregular surface. For instance, you might arrange different sized cans, a cup and a saucer as in the illustration. Impregnate long strands of steel wool with cement and water until you have a thick, rope-like mass that you can drape over the cans, cups and saucers so it curves in all directions, from side-to-side as well as up-and-down. Cover and let set overnight.

The next day wet the design and carefully pry it loose. If the design seems strong enough to handle wind wires around it in a spiral pattern extending the length of the piece. If you want the finished design to stand vertically let several free ends of wire branch out in a radiating manner from the bottom end to outline the base. Brush slurry between and under all wires and pack fresh fiber-cement between and over the wires. Add more fiber-cement where you want to extend the form.

If the design should accidentally break you can repair it as described above for the other figure. The broken and repaired form may have a more interesting line than it had before breaking. You may even want to improve the form by deliberately breaking it and then cementing it together at a different angle.

The next day further reinforce the base by winding wires around the base and extending these wires up the stem so the design is firmly attached to the base.

You will now see your design growing and changing as you add fresh mix each day to develop curves and masses that create its individuality. When finished cure the cement by keeping it wet as discussed above.

USING CEMENT SAFELY

Fortunately cement can be used safely by anyone willing to observe a few precautions. The alkalinity of cement mixtures can irritate the skin and cement dust can irritate the eyes, nose, throat and bronchial passages so adequate ventilation must be provided when opening the sack and taking out cement. Avoid breathing the dust. If you store the cement sack out-of-doors in a steel garbage can and do your mixing outside, the mixture will be wet and dust free to use indoors. Rubber gloves that also cover the wrists will protect the hands. If a cement mixture should accidently be splashed into an eye a serious injury can result so if any cement enters an eye, rinse immediately and repeatedly with water and get prompt medical attention. Ordinary prescription glasses provide minimum eye protection but the face and eyes are best protected by a full face shield which is supported by a comfortable head band and does not interfere with glasses or vision.

The face shield and rubber gloves should be washed frequently. After washing the insides of the gloves turn them inside out and hang them up to dry. Having two pairs of gloves allows one pair to dry while using the other. Clean all tools, mixing basins and rubber gloves in a bucket of water so you can dispose of the wash water outside. Avoid washing cement away in a sink as cement can harden in drains. If cement accidentally gets into drains flush for several minutes with cold running water.

1. On a sheet of plastic shape the fiber-cement into a simple form — long neck with no head, stumps for arms and oversize feet.

2. The next day you can pick up the fiber-cement and with a sharp knife whittle away excess material.

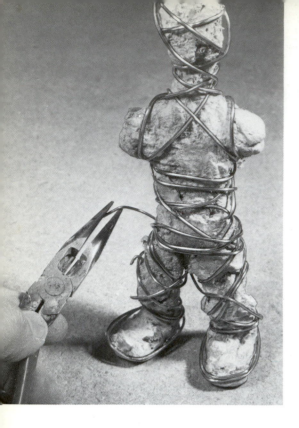

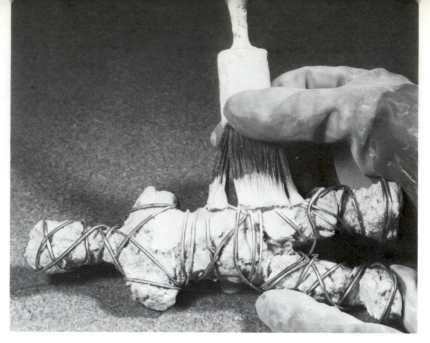

4. Mix cement with water to make a slurry and brush it on the figures and under all wires.

3. Wind small gauge wire about the figure to reinforce it.

7. Bend the arm and press it against the body.

5. Push fresh fiber-cement on the figure.

6. Fasten a roll of fiber-cement to the shoulder.

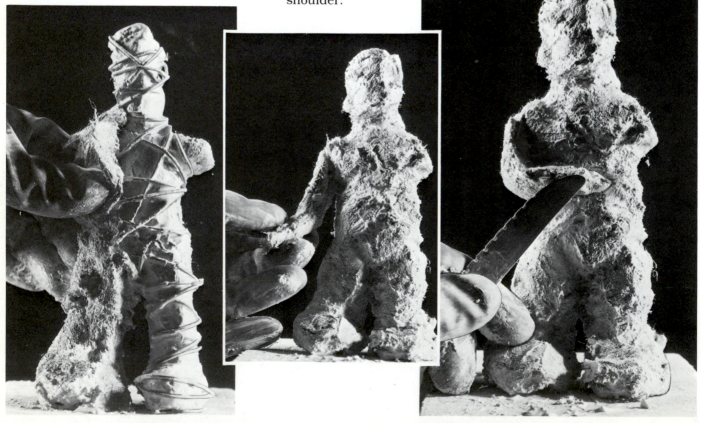

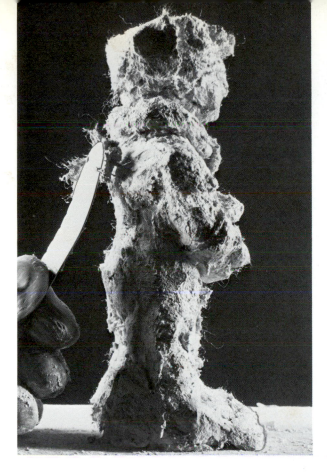

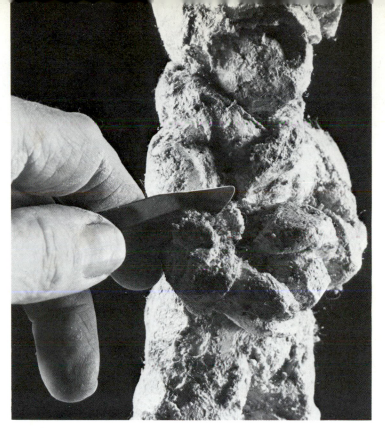

9. As the cement sets trim the form with a knife.

8. Add bits of fiber-cement to build up the form.

10. Carve small details with the sharp point of your knife.

While working on the piece, spray frequently with water.

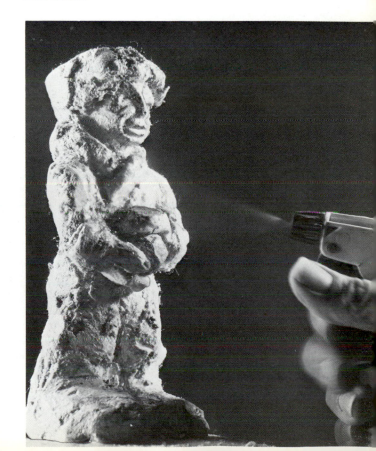

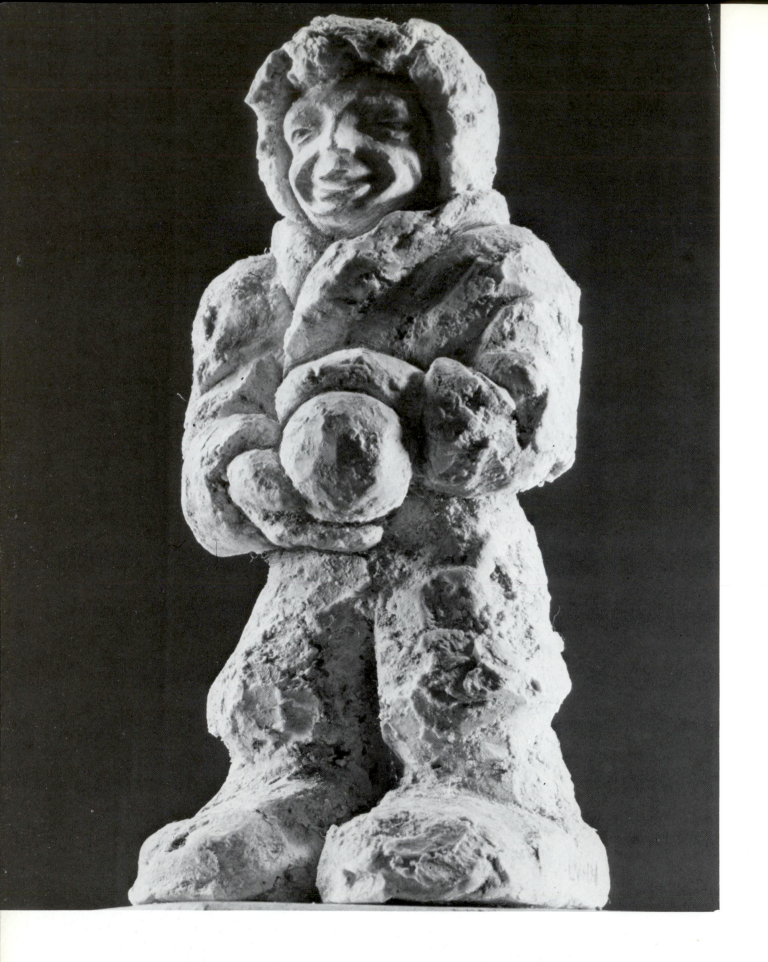

David, 6 inches (15 centimeters)

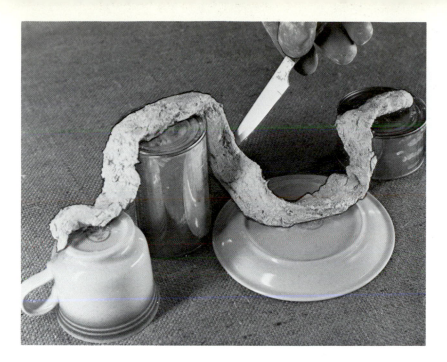

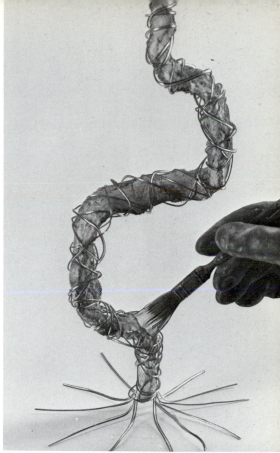

1. Make a rope of fiber-cement and drape it over objects of differing size so it bends in all directions. After the cement sets firmly gently pry it loose.

3. Add more fiber-cement to the design and fill between the branching out wires.

2. Wind spiral turns of wire about the design and place several branching out wires at one end. Brush on slurry.

4. Add more material and widen the base.

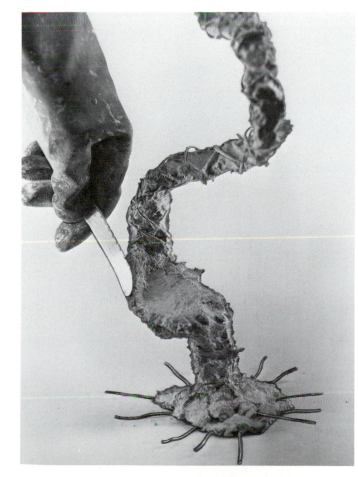

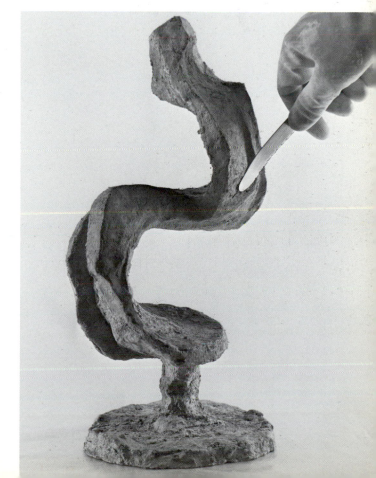

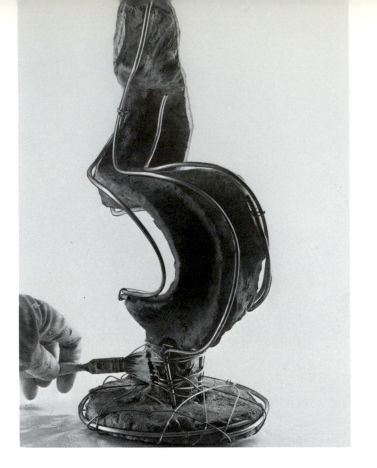

5. As the cement sets trim with a knife.

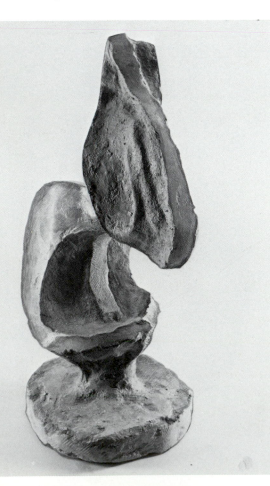

6. As the design grows add more wires. Note how these wires run through holes drilled in the base and how thinner wires encircle them to stiffen the stem.

7. Shape the final form and trim with tools.

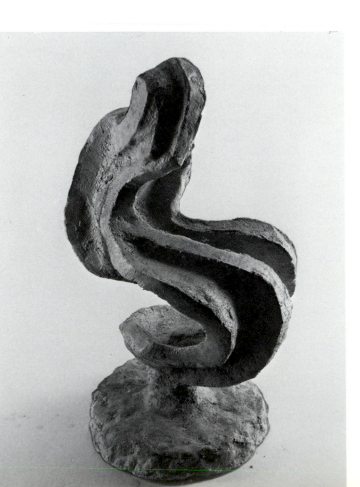

III. Sculpting With Sand-Cement

The most workable mixtures are made with a fine grain sand such as fine grain silica sand packaged in 100 pound sacks and available at lumber yards and masonry supply dealers. Masonry sand or beach sand will serve as well if it is sifted to remove the larger particles. An ordinary window screen can be used for sifting. If the sand contains clay, soil or other dirt it should be washed by putting the sand in a bucket, adding water to fill, stirring vigorously, and pouring off the wash water. Repeat as often as necessary.

Cut off several feet of wire, preferably 20, 18 or 17 gauge, and fold the wire upon itself several times until you have about twenty or more wires in a loose bundle about ten inches long. Bend this bundle of wires into any desired shape including arms and legs if desired. Bend several wires at one end to outline the base. Since you will be pushing a sand-cement mixture into these wires add more wires if they seem needed to hold the mixture in place. If some wires spread too much wind one wire around the bundle but keep the wires loose enough to receive the mixture. What you now have will resemble a wire sculpture in which each member contains about ten or more wires.

Begin mixing with approximately equal amounts of sand and cement. Strong and durable results are obtained by using as little water as possible so add the water sparingly and only enough to keep the mixture workable. Squeeze and knead the mixture until it develops a smooth, plastic feel. Try to push this mixture between the wires and roll the wires between your fingers so the cement paste contacts all wires. If the mix refuses to stay in place add a little more water, mix thoroughly and again push it between the wires. Continue adjusting the proportions of cement and sand until you find the mix that works best. If the mix refuses to squeeze in between tightly spaced wires spread these wires with your knife. If some wires pull away from the mix they can be left exposed and covered after the first mixture sets.

Cover the design with a plastic bag and let the cement set overnight. The next day wet thoroughly and keep it wet until you work on it again.

During your second work period add more wires to strengthen critical sections such as where the base connects to the legs or stem. Prepare another mixture and this time use more sand and less cement than in the first mix. Brush slurry on the design and then use the bent-end knife to apply the fresh mixture. Add only as much as will remain without falling off. The next day this mix will have set and more can be added to enlarge any section. If necessary to enlarge a section without waiting you can attach more wires in that section to build up the desired mass and then pack fresh mix into these wires.

SURFACE REINFORCEMENT

Since the greatest stresses occur in the skin of any design steel reinforcement should be placed close to the surface. When you have expanded the design almost to its finished form wind small gauge wires around it in a spiral manner. These wires can be as fine as 28 or 32 gauge and placed as close together as possible. Brush slurry under the wires and then apply enough mix to cover them with at least a sixteenth inch (two or three millimeters) of mix to prevent rusting. If desired, some wires can be left exposed at the surface to rust and add a rusty color.

As you apply the final mixture try to leave an interesting texture of tool marks that will enhance the surface qualities. An hour or two after applying sand-cement it will have set firmly enough so it can be carved with a knife and you may want to carve out details and textures at this time.

LARGER DESIGNS

This same procedure can be modified to build designs of any shape, size or complexity. Later chapters will describe techniques for building heads, busts, figures, animals, shell designs and stained glass designs.

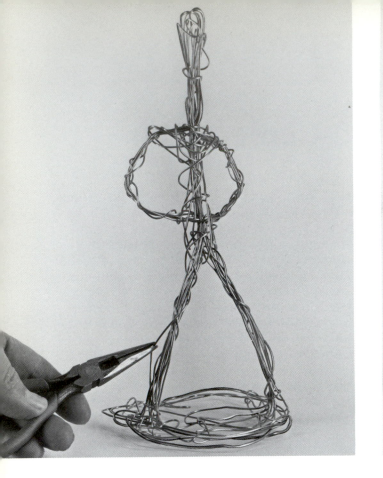

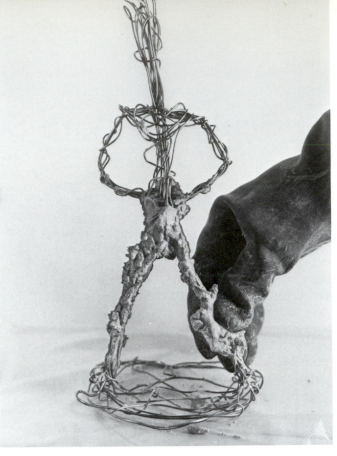

1. Bend wires so that each member contains several in a loose bundle.

2. Pack in a sand-cement mixture so that cement gets between all wires.

3. After the cement sets, apply spiral turns of wire, brush on slurry and add more sand-cement.

4. Tool mark the surface as you finish.

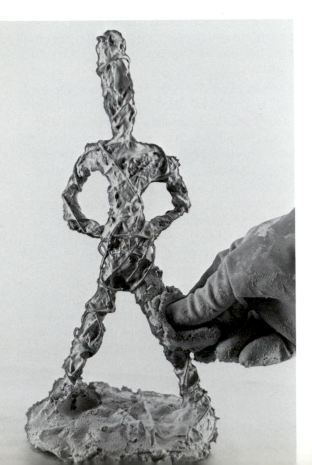

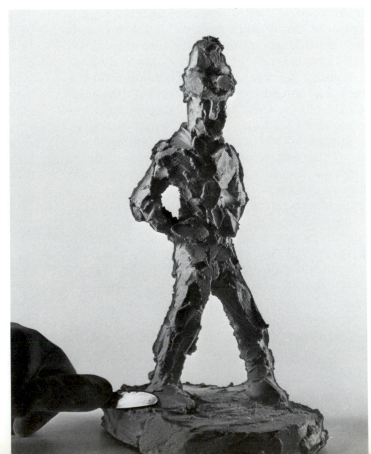

IV. Designing for Strength and Durability

The strength and durability of cement depends upon its density—low porosity and low permeability.

Cement hardens and develops its strength by combining with water—by *hydration*. But cement can combine with only a limited amount of water. Only about 24 grams of water can combine with 100 grams of cement. Any mixing water in excess of this limited amount will eventually evaporate to leave tiny, connected pores which reduce the density and strength. Later these pores can fill with water to freeze and exert an expansive pressure which, when repeated enough times, can rupture the cement. Water freezes first in the largest pores and in the very smallest pores may not freeze. To reduce the size and amount of pores and protect against freeze damage mix with as little water as possible.

Cement with water alone (no sand, steel, or fibers) is *neat* cement or cement *paste*. The cement paste in a mix is known as the cement *matrix*. As hardened cement paste dries it gives up the excess water and shrinks. This develops tensile stresses and since the matrix is weak in tension microcracks appear to relieve the tensile stresses. The more excess water the more shrinkage and the more microcracks which can widen into visible *drying shrinkage cracks.*

The surface tension of the water in the pores pulls inward on the sides of the pores and this contributes to shrinkage. Shrinkage reducing agents reduce the surface tension of the pore water to reduce the shrinkage and this can reduce the size and amount of cracks due to drying shrinkage.

Aggregate, such as sand, does not shrink. But any aggregate, powder, pigment or fiber requires additional water to wet their surfaces and this added water produces more shrinkage. The shrinkage cracks may be hidden in the matrix between the aggregate and not be noticed. Fibers can prevent microcracks from widening into visible cracks (pages 22, 105). Latex polymers increase the flexibility of the matrix to eliminate most shrinkage cracks (page 20).

Since strength and durability depend upon using as little water as possible the *water-cement ratio* (the weight of the water divided by the weight of the cement) is critical to any mix. For example, 30 grams of water with 100 grams of cement is a water-cement ratio of 0.30. The water-cement ratio can be estimated by the stiffness of the mix. The stiffer and drier the mix, the lower will be the water-cement ratio, the lower will be the porosity and permeability and the more

durable will be the matrix.

Superplasticizers (high-range water reducers) lower the water-cement ratio by giving each cement particle a negative electrical charge. This makes the particles repel each other to reduce friction and make the mix more workable with less water. They can reduce water over 30% for more strength and durability. A mix with a superplasticizer may sag slightly after being applied. To control this use less water and include fibers.

SETTING, CURING AND HARDENING

Cement begins to hydrate as soon as water is added. Within fifteen or thirty minutes, depending upon the temperature, *initial set* occurs and the mix loses its plasticity and workability. Avoid the temptation to add more water at this time as that will raise the water-cement ratio. In hot weather setting is faster and the working time, or pot life, is shortened. To extend the workability time in hot weather use ice water and use cement and aggregate that has been stored in a freezer. Float the mixing basin in a larger basin containing ice.

Chemical retarders can extend the pot life (handling time) by postponing the set. Some retarders also extend the hardening time after set. A desirable retarder extends the pot life while allowing hardening to proceed normally. One retarder has two phases: a stabilizer which can retard setting indefinitely and an activator to neutralize the stabilizer when setting is required. In very small doses the stabilizer extends the pot life adequately and the activator is not needed.

In hot, dry weather *plastic shrinkage cracks* can appear soon after initial set and are caused by a rapid evaporation of water in the surface. Unlike drying shrinkage cracks these cracks run deep and can become structural defects. They should be filled with a polymer modified slurry and more cement mix (page 25). They may be prevented by protection from wind and heat. Fibers may help prevent them.

Several hours later, depending upon the temperature, *final set* occurs and the cement is firm enough for water to be added to the surface to prevent loss of that needed for maximum hydration, or *curing. As* soon as a moistened finger can be rubbed vigorously upon the surface without picking up any cement it is time to add curing water. To develop maximum strength and durability water must be present to combine with as much cement as possible for the

hydration that continues for many months at a decreasing rate. Keeping the surface wet prevents evaporation of the essential water and four weeks of wet curing develops most of the strength and durability. Latex polymer in the matrix reduces the wet curing to two days because the polymer forms a moisture barrier that keeps the water inside the matrix for continued curing. A polymer modified matrix kept wet for more than two or three days loses strength. After two days of wet cure a polymer modified matrix should be allowed to air dry.

Raising the temperature accelerates hydration and steam has been used to shorten the curing time. But high temperatures produce larger pores that reduce durability. For maximum durability curing temperatures should be kept moderate.

ENTRAINED AIR

Air-entraining cement incorporates microscopic bubbles of air during mixing. These tiny bubbles of air improve the workability with less water and so can lower the water-cement ratio. Unlike the connected pores left by excess water these bubbles are separate from each other. They reduce freeze damage and improve durability. They are most effective with moderate to high water-cement ratios. Properly entraining the air when mixing by hand can be difficult – a bubble spacing of less than 0.008 in. (0.20mm) is recommended. Latex polymers also entrain air and using them with ordinary cement at very low water-cement ratios should be as effective as air-entraining cement without polymers.

POLYMER MODIFIED CEMENT

Latex is a dispersion of organic polymer particles in water. The water combines with the cement and the polymer particles combine with each other to form a continuous polymer matrix throughout the cement matrix–a polymer-cement co-matrix. The polymer bridges over microcracks in the cement and can eliminate most, and sometimes all shrinkage cracks. Polymers reduce porosity to improve durability and resistance to freeze damage. Polymer particles coalesce only at or above the *minimum film forming temperature* so hardening and curing should be above that temperature (provided by the manufacturer).

Surfactants are added to the latex to prevent coagulation of the polymer particles while mixing. These surfactants also improve workability and reduce the water-cement ratio. Polymers are not used with air-entraining cement as the polymers entrain air bubbles. If these bubbles are small enough and spaced close enough they can provide freeze protection. Larger bubbles are often exposed when finishing the surface. These can be filled with polymer slurry and polymer modified cement.

In hot, dry weather water evaporates rapidly from the wet mix and some of the polymer may coalesce and coagulate while mixing and the mix can lose its workability. Retarders can help to prevent this and cooling the mix (see page 19) can also prevent the coagulation. Refrigerate (do not freeze) the latex before using it.

Latex polymers are excellent bonding agents. A slurry with cement mixed in the latex to a thick consistency and brushed on the hard surface improves bonding when the fresh mix is applied to the wet slurry. Superplasticizer in the slurry improves contact. Silica fume can be added to the slurry (see page 23). Always apply the fresh mix before the slurry dries. Polymers bond to tools and gloves so frequent cleaning is necessary.

Optimum qualities are usually obtained with about 15% to 20% polymer solids to cement (by weight). With some polymers adhesion improves at higher ratios. Since the polymer solids vary with different latexes, and since the water-cement ratio varies, a rule of thumb suggests using the latex as packaged if it has 25% to 30% solids and adding water to dilute it if the solids ratio is higher. Consult manufacturer for specific advice.

Qualities also depend on the *glass transition temperature* (Tg). Polymers with a low Tg make a more impermeable and more flexible co-matrix with a lower modulus of elasticity; those with higher Tg develop more hardness and strength.

Acrylic, styrene acrylic and styrene-butadiene latex polymers have long been used in outdoor exposure with excellent results. Polyvinyl acetate is not water resistant and is not for outdoor use. Other polymers of recent development may prove to be weather resistant. The styrene-butadiene may yellow with time while the acrylic retains the original color of the matrix. Some polymers are available as dry, redispersible powders to be added to water.

Special epoxies can be mixed with cement to improve its qualities and epoxies for bonding fresh cement to hardened cement are available. Epoxies can cause adverse health effects and they require compliance with proper safety precautions.

STEEL REINFORCEMENT

Because of its high elasticity steel changes shape very little under stress and can absorb very high stresses without permanently changing shape. When steel is embedded in hardened cement it can absorb the stresses that would have ruptured the cement. As cement dries and shrinks it clamps down on the steel to prevent slippage.

Consider a steel reinforced cement member under increasing tensile stress. Within the elastic limit *stress* and *strain* (stretch) are proportional. The steel and cement both stretch under the tensile stress but the cement cannot stretch as much as the steel under increasing stress. The cement reaches its elastic limit and cracks while the steel continues to stretch. Water can enter the cracks to corrode the steel. To prevent corrosion use enough steel to absorb all stresses without stretching enough to crack the cement and make certain that all steel is in complete contact with the cement.

Since the greatest stress develops in the surface steel is most effective when close to the surface. But steel in the surface is more in risk of corrosion. Placing stainless steel near or in the surface will provide steel where it is most needed without risk of corrosion. For best results use stainless steel throughout the design.

Steel reinforcement is most effective when it is well distributed. Many thin rods and wires are more effective than one thick rod. A combination of thick and thin steel is the most practical. This intimate arrangement of steel and cement is known as *ferrocement*. Shape the design with many steel wires and rods and push the cement mixture into them. Add more steel and more cement to develop the design.

Consider the design as a steel sculpture where the steel rods and wires are bonded with cement which also provides them with lateral support so they can develop their strength.

BENDING STRESSES

Any linear member, such as an arm, leg, neck, branch or stem is subject to bending so the greatest tensile and compressive stresses develop in the surface with almost none along the central axis. The primary steel reinforcement is placed close to the surface with only enough cement cover to prevent corrosion. It accomplishes nothing to place a heavy steel rod along the central axis. Rods (or heavy wires) run longitudinally along the length of the member with thinner wires wound spirally around them to prevent outward buckling of the longitudinal steel. The spiral wires also absorb the shearing stresses.

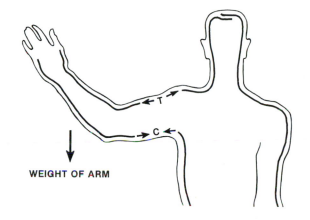

As a linear member bends tensile stresses develop on one side and compressive stresses on the other side. The greatest stress occurs in the surface. Shearing stresses develop along the central axis.

Its own weight bends the outstretched arm downward. Tensile stress develops along top of arm at "T" and compressive stress along bottom of the arm at "C." Longitudinal steel reinforcement is placed close to the surface along top and bottom of the arm to absorb these stresses. This steel runs into neck, head and torso where it overlaps other steel rods or wires.

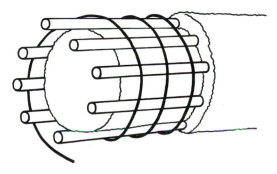

Since the arm could bend from front to back as well as up or down, longitudinal steel rods or heavy wires are placed on all sides close to the surface. Small gauge wire is wound about the longitudinal steel to prevent outward buckling and to absorb shearing stresses. All steel is covered with enough cement mix to prevent rust. All linear members, either vertical or horizontal, can be reinforced in this manner.

PORES AND CORROSION

Steel and cement expand and contract almost the same with temperature changes so they bond well. Hydrating portland cement produces alkaline calcium hydroxide to create a passivating oxide on the steel and as long as the alkalinity remains high enough it prevents corrosion. But carbon dioxide can penetrate pores to react with the calcium hydroxide, reduce the alkalinity, destroy the passivating oxide and begin corrosion. Oxygen, acid rain and chlorides can also invade pores to corrode steel. Chloride set accelerators promote corrosion and should be avoided.

Low porosity controls corrosion by blocking the invasion of water-borne corrosive agents with a more impermeable matrix. (See POZZOLANS below.) One pore-reducing admixture (an alkaline earth silicate) converts the calcium hydroxide (free lime) into hydrates of calcium silicate to reduce the pore size. This admixture is white so it retains the color of white cement in the sculpture surface.

Cement prevents corrosion only when it is completely in contact with all the steel surfaces. To obtain this condition with the stiff mixes of low water-cement ratio can be difficult especially when the steel is closely spaced. To obtain good contact brush a polymer modified slurry on the steel before pushing the stiff mix between the wires and rods.

Calcium nitrite is claimed to inhibit corrosion by improving the passivating oxide on the steel. It also accelerates setting. A combination of organic esters and amines is claimed to form a film barrier on the steel and also to screen out chlorides. Another rust inhibitor produces vapors that migrate through the hardened cement matrix to reach the steel and form a monomolecular film on its surface. This migrating inhibitor can also be added to the fresh mix before placing it on the steel. No corrosion inhibitor should be considered permanent as their effect diminishes with time.

If all steel reinforcement is in electrical contact an external electric current applied to the steel will reverse the electro-chemical corrosion process and prevent corrosion. This is known as cathodic protection.

Some rebars are epoxy coated to prevent corrosion. The epoxy is easily broken while handling and bending and rust can begin in the damaged epoxy areas.

Copper, bronze and brass may retard setting where they contact cement but they are stable in cement. Nickel, chromium, silver and tin resist corrosion.

Cement forms a passivating layer on zinc (hot dip galvanizing preferred) to inhibit corrosion.

Aluminum corrodes in cement. It stretches three times as much as steel under the same stress.

Different metals in the same moist matrix can produce an electric current to develop bi-metallic corrosion. Steel coated with another metal can corrode when in contact with bare steel in a moist matrix.

Carbon, aramid and glass fibers, embedded in plastic resin, make non-corroding reinforcing rods. Carbon fibers, with strength and elasticity comparable to steel, make the strongest rods, and the thinner rods can bend to follow contours. Glass fiber rods, because of low elasticity, stretch excessively and the glass fibers can deteriorate in cement.

Stainless steel provides the best elasticity, strength, ductility and corrosion prevention. Austenitic stainless, such as the 304 and 316, performs well in cement with the 316 the more corrosion resistant under severe conditions. Stainless is worth its expense for an outdoor sculpture exposed to many years of freeze-thaw, air pollution and acid rain.

For good bond reinforcing should be free of rust, oil, dirt and paint. Metals often have an invisible film of oil. Clean all metals with silicon carbide paper or other agent.

FIBER REINFORCEMENT

Steel, bronze, aramid and carbon fibers mixed with cement can prevent microcracks from widening into visible cracks. Controlling cracks increases the tensile strength of the matrix. Fibers with small diameters can modify the mix into a sensitive modeling medium. The more fibers in the mix the more they impart their unique properties to the matrix. Careful hand mixing can achieve high concentrations of long fibers. To make sure that all fibers are in complete contact with cement place them in a cement slurry (with latex polymer and superplasticizer) and spread them until they are completely impregnated with slurry. Silica fume will help disperse the fibers. While mixing add more cement gradually to produce a mix with good modeling qualities and low water-cement ratio. Continue spreading the fibers apart while mixing. If the fibers ball up cut through them with a knife or pull them apart. (See page 105)

POZZOLANS

Pozzolans are mostly amorphous silica (silicon dioxide) that converts calcium hydroxide into calcium silicate hydrates which improve durability by reducing porosity. Their fine particles also fill spaces between the cement particles to reduce pore size.

Fly ash is about 35% to 60% silica. Silica fume particles are smaller than those of fly ash or cement and are over 90% silica. Rice husk ash is about 90% silica with particles larger than silica fume. High reactivity metakaolin (52% silica, 44.6% Al_2O_3) with particles larger than silica fume forms calcium silicate and calcium aluminate hydrates.

Calcium hydroxide accumulates at the interface where the cement contacts the aggregate, wire, rod or fiber to make this zone the weakest part of the matrix. Pozzolans convert the calcium hydroxide at the interface into calcium silicate hydrates to make a strong interfacial zone with strong bond. An interface occurs where a fresh mix is applied to a hardened cement surface. Pozzolans in the polymer modified slurry that is brushed on the surface before applying the fresh mix (page 20) improves the quality of that interface. The same slurry can be applied to steel rods and wires before applying the fresh mixture.

Metallic corrosion is an electrochemical process. Silica fume increases the electrical resistivity of the cement matrix and at 12% of the weight of the cement silica fume produces enough electrical resistance to prevent corrosion. Higher percentages further improve durability by reducing porosity.

Complete dispersion of silica fume is necessary and requires careful mixing to break up clumps of particles. Add silica fume and superplasticizer to the latex polymer with only a little cement and mix vigorously. Add fibers and gradually add more cement while continuing the vigorous mixing. Available as a dry powder and as a wet slurry, the wet slurry has a darker color but disperses the particles easier.

Carbon makes fly ash, silica fume and rice husk ash gray. They turn white cement gray. Some silica fume has less carbon and turns white cement a softer gray. High reactivity metakaolin is very white and does not alter the color of white cement. It can be used in the surface of the sculpture with white cement, pigments and fibers to develop patterns of color and texture. Its pozzolanic activity reduces porosity to improve durability. Available in two grades, the extra-fine has the smaller particles.

All pozzolans require more water to wet the particles and this can raise the water-cement ratio enough to cancel the benefits. With silica fume, fly ash, rice husk ash and metakaolin always use a superplasticizer to reduce the water-cement ratio.

PORES AND SURFACE TREATMENTS

Treatments of the cured cement surface may protect against acids and alkalies and some can enhance the esthetic qualities. Those that penetrate the pores–usually silanes and siloxanes–can prevent water from entering the pores while allowing water vapor to pass out through the pores. They may prevent acids and chlorides from invading the pores. By allowing water vapor to pass they avoid an accumulation of water that could cause freeze damage. Unfortunately they do not always penetrate as much as claimed, their effect is not permanent, and they are no substitute for a matrix with low porosity.

Protective coatings form a film on the surface and some may also penetrate the pores. Those based on methyl methacrylate do not yellow. They protect against acids, alkalies and stains and facilitate cleaning. They repel water but allow some water vapor to pass. They are available in a water emulsion and in a mineral spirits solvent that dries to a high gloss. On a smooth surface the water emulsion can be polished to a gloss by rubbing with gloved fingers as it dries and then buffing with a soft cloth.

Some acrylic coatings are flexible and stretch to bridge over cracks in the cement. They can be mixed with pigments and textured before drying. Epoxy and urethane coatings are also available.

Coatings may be durable but the gloss of the coating may not be permanent in outside weather and may grow dull after years of exposure.

SPECIFICATIONS AND STANDARDS

Most reliable products are tested according to standards of the American Society for Testing and Materials (ASTM). When selecting a product obtain specifications from the manufacturer for valid testing reports and for compliance with ASTM standards. See the Appendix for other professional organizations that offer recommendations.

SAFETY PRECAUTIONS

Observe all safety precautions recommended by the manufacturer when using any of the compounds or products discussed above. Avoid contact of these materials with the skin, mouth or eyes and avoid breathing of their vapors. If accidental contact occurs, wash with soap and water. If they get into the eyes, flush with abundant water and obtain prompt medical attention.

Compounds can react with each other. When using two or more admixtures or polymers in one mix always add each separately to the mix. Make trial mixes to find the best dosage, sequence of addition and the effect upon ultimate strength.

V. Texturing, Coloring and Polishing the Surface

TEXTURES IN FRESH CEMENT

As you apply the fresh cement with a tool such as the knife blade or with your gloved fingers you will notice a unique texture developing. Each tool leaves its own mark. Each person applies material in an individual style. These marks and style can achieve an attractive textural pattern. Try adding small pats of fresh material to build up the form and note the textural pattern that develops (see page 63). Try cutting grooves in the fresh surface to create a linear texture (see page 92). Fibers develop unique textures. A coarse grade of steel wool creates a rough and bristled texture. As the exposed fibers rust a tint of earthy red stains the white cement surface.

TOOL WORKING THE HARDENING CEMENT

The gradual hardening of cement can facilitate tool working to shape it into smooth contours. As soon as the cement sets it becomes firm enough to be cut with a coarse rasp. Even sand-cement can be rasp cut while still soft. Since fibers are softer than the rasp the fiber cements can be tool worked as they harden. As soon as the cement is firm enough to hold the fibers cut across the surface with a coarse rasp. As the cement hardens further use a finer rasp or file. Follow with silicone carbide paper. Begin with the coarsest grades and when the surface is fully hardened finish with the 400 or 600 grades of silicon carbide paper to reveal the textural pattern of the fibers. Color and value variations will appear where some areas have more fibers and others have more white cement. Steel fibers produce gray lines and areas. Bronze fibers create delicate blue lines. Carbon fibers produce a pattern of fine black and gray lines in the white cement.

The grooves from the coarse rasp can be left for their textural qualities or they can be filled with cement of a contrasting color. After the cement hardens remove enough material to expose the cement in the grooves as a pattern of lines.

Note that tool working need not be applied to the entire surface. Leaving the recessed areas untouched and only working the higher areas will develop a pattern of rough-to-smooth textures.

To avoid airborne dust keep the surface wet while working with tools or silicon carbide paper.

PIGMENTS AND COLOR

Pigments can be added while mixing for a wide range of color effects. The alkalinity of cement alters many pigments and each should be tested in small samples with white cement to evaluate its relative permanence. No pigment will be completely permanent but even if it loses much of its color it may have enough left to justify its use.

The muted earth colors and iron oxides are used in concrete because of their alkali resistance and low cost. But many other more expensive compounds such as those in artists' paints may retain much of their color in cement. Pure pigments are available in powder form but small amounts of artists' acrylic, water-color and even oil paints can be used as a source of pigment. By limiting their use to the surface their expense can be minimized. Some pigments will affect the setting and hardening of cement so each should be tested for this effect.

Water is required to wet the pigment and this can raise the water-cement ratio but a superplasticizer can reduce this. Some superplasticizers may add their own tint. Styrene-butadiene polymer will alter the color of the pigment slightly. Pigments should be limited to ten percent of the weight of the cement.

To obtain a varied color pattern add the pigment after the cement has been mixed and do not mix the pigment in uniformly. To each small batch add a different amount of pigment. When silicon carbide papers finish the surface they will reveal interesting color variations. Add two different pigments and again do not mix in completely. The finished surface will reveal three colors, the two original pigments and the mixed color with intermediate variations.

White cement brings out maximum color potentials. Gray cement added to white creates a warm gray tint. Silica fume creates a cool gray in white cement.

Bronze or copper powder in white cement creates a delicate blue tint. Copper slows the setting of cement so use sparingly. Copper or bronze wool leaves fine blue lines in white cement when finished with silicon carbide paper (page 33). Copper or bronze wire surface reinforcement when cut into by a file will appear as lines of metallic luster. Protect the luster against corrosion with a sealer.

BURNISHING

After the surface has hardened and while dry it can be burnished to a gloss. A rough surface can be burnished with a rotary steel wire brush in an electric drill. Try the brush at different curing ages to determine the optimum hardness for burnishing. Avoid the airborne dust. A smooth surface can be burnished by rubbing with the side of a knife blade. The dulled teeth of a dull riffler or other dull rasp will leave burnished grooves. Burnished surfaces need a protective coating.

SHRINKAGE CRACKS

The cracks caused by drying shrinkage can be widened with a sharp knife and then filled with a polymer modified cement paste of a contrasting color. Refinish the surface with silicon carbide paper for an intriguing line pattern where the cracks had been.

EXPOSED AGGREGATE

Aggregate in white cement can be exposed by scrubbing away the surface cement with a stiff brush after it has set enough to hold the aggregate in place but before it has hardened enough to prevent removal of the cement. The protruding particles of aggregate can create an attractive pattern depending upon the color and shape of the particles. After further hardening of the cement a rasp or file can cut into the surface and cut through the aggregate to expose their interior qualities. Silicon carbide papers can then reveal the esthetic qualities of the polished aggregate.

Expanded shale, clay and slate are lightweight aggregate that can be cut with rasps, files and silicon carbide paper to reveal a pattern of soft colors.

Ceramic spheres are lightweight and easily cut to expose the voids inside the spheres. When filled with white cement and then finished the voids make an intriguing pattern.

Blast furnace slag can be cut and polished to a luster with a fine grade of silicon carbide paper.

Pieces of colored plastic in white cement can be

exposed and finished to a pattern of colors.

Particles of elemental silicon can be exposed and polished with fine silicon carbide paper to a high mirror-like luster that does not corrode.

REPAIRS

The rasps and files will expose air pockets and voids in the fiber-cement. The small air pockets are unavoidable especially when using latex polymer which entraps tiny air bubbles while mixing. Small holes can be filled with a polymer modified slurry and thick cement paste, left to harden and then refinished with silicon carbide paper. Some of the fibers may not be completely mixed with cement. These imperfections can be left for their textural value or they can be removed with a sharp knife or a narrow chisel. Tool working may expose small gauge steel wires that are close to the surface. These can be cut out with a narrow chisel. Cut the edges of these repair holes almost perpendicular with the surface. Refill and refinish as in the drawings.

Brush a latex polymer slurry into the hole, pack the fresh cement mixture into the hole and let excess material extend above the hole and beyond the edges.

After the cement sets firmly, cut away most, but not all of the excess with a rasp.

After the repair cement hardens to almost the hardness of the surrounding material, remove the remaining excess with a file and silicon carbide paper.

After refinishing, the repaired areas will appear as slightly different in value from the surrounding material and this will increase the variety of surface textural pattern.

25

VI. Sculpting the Head

A sculptured head needs a base and since the shoulders and chest make a convenient base perhaps the easiest method is to include them in your design. Outline the head and shoulders as illustrated in the photos and build the sculpture upon this wire form so as to leave a hollow space inside. As the work proceeds apply one or more layers of cement mix inside the hollow space to cover the wires on the inside. When curing this design turn it upside down inside a plastic bag and fill the hollow space with water. Wet the outside and then tie the bag around it.

This method can be modified to build the head solid. Make a wire frame, pack it with sand-cement as described in Chapter 3, add more wires and more sand-cement. The shoulders can be left off to let the neck and long curls of hair serve as the base.

The head that is mounted above a base requires an armature made from lumber as shown in the drawing. To produce a hollow space inside the head build a core on the armature with newspapers bound with duct tape or other water-resistant tape. This core will have the shape and size of the hollow space. Since the shell of the head will be about an inch thick (2.5 centimeters) subtract about two inches (five centimeters) from the finished head size to determine the size of the core. To remove the newspapers and tape from the finished head bend the end of a heavy wire into a small hook that can reach in through the neck. When curing this design turn it upside down and fill with water as described for the other hollow design.

A head of this design is best mounted on a two part base in which the upper part of the base is smaller than the lower part. A later chapter will describe how to build such a base.

1. Outline the head and shoulders with nine gauge wire.

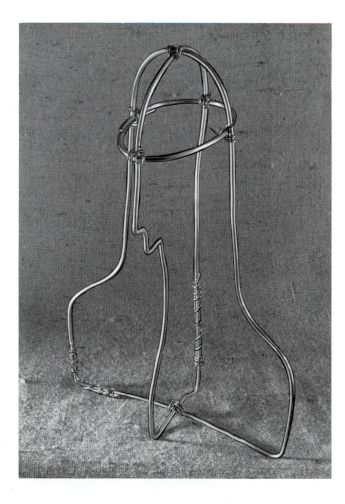

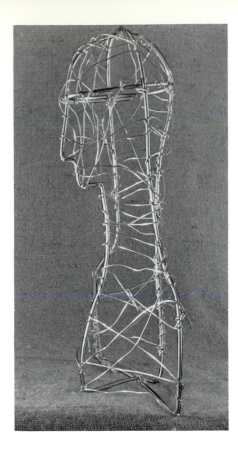

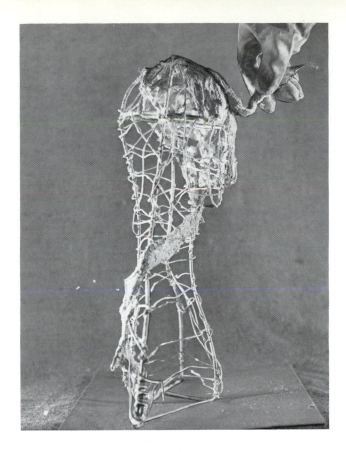

2. Wind small gauge wire around the heavy wire.

3. Apply fiber-cement.

4. More small gauge wires to reinforce the next layer.

5. Brush slurry and pack sand-cement over and under the wires.

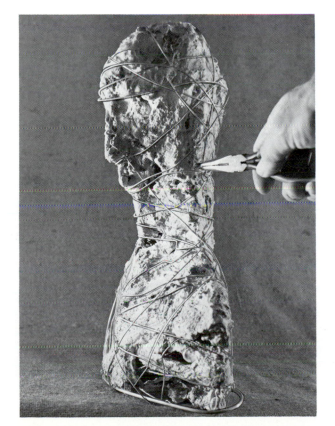

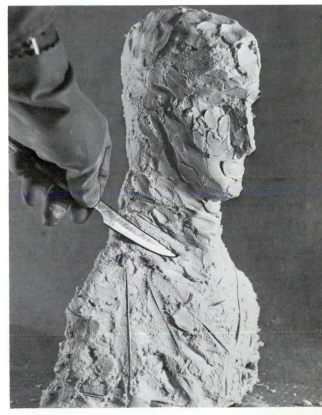

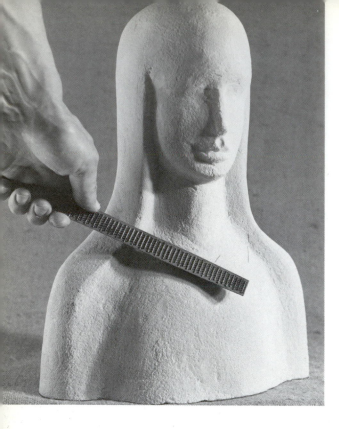

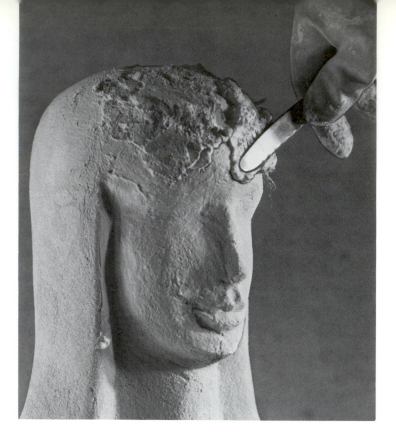

6. As soon as the cement sets and before it begins to harden modify the contours with a dull rasp or knife.

7. Brush on slurry and apply a thin layer of fiber-cement.

8. When the fiber-cement has set firmly trim with a rasp or sharp knife.

9. A riffler rasp works well in concave areas.

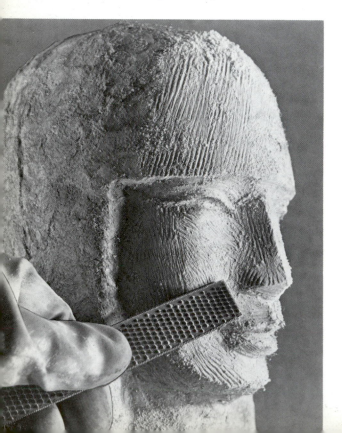

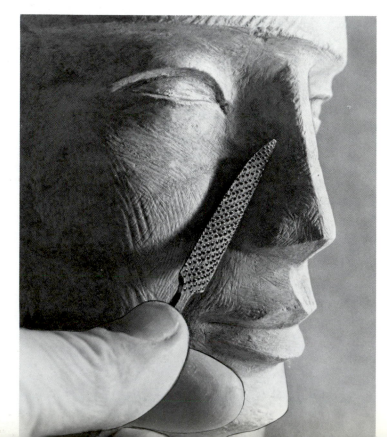

Finish with silicon carbide paper and, after cement is thoroughly dry, coat with methyl methacrylate and buff. Carnauba wax can be added to enhance the gloss.

Viking, 17 inches (43 centimeters)

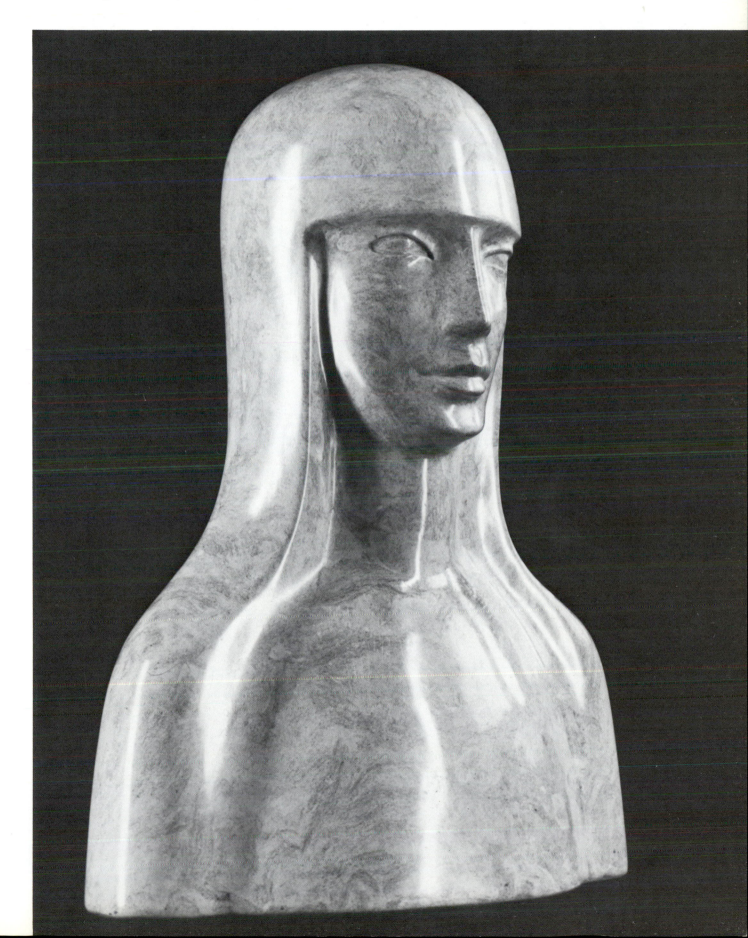

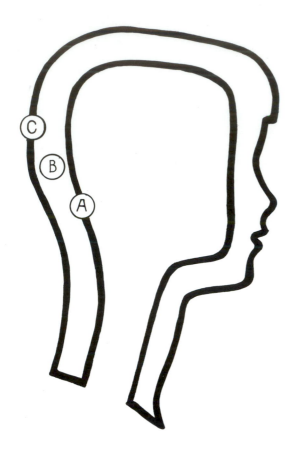

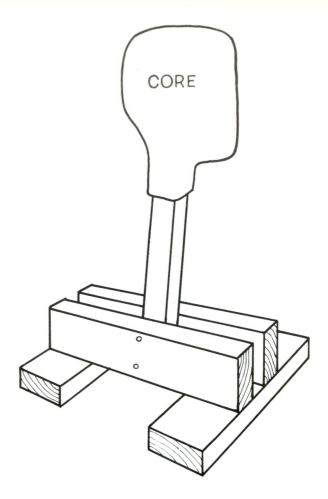

The hollow head and neck can be built in three layers. The inside layer "A" and the outside layer "C" are both fiber-cement. In between them layer "B" is sand-cement and which contains the steel reinforcement.

The armature can be built of 2 by 4 lumber with a 2 by 2 center post to hold the core upon which you build the head. Incline the center post slightly forward to aline it with the axis of the neck.

1. The core can be made of newspapers wrapped with waterproof tape such as duct tape.

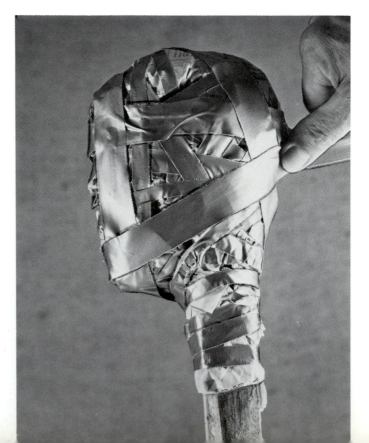

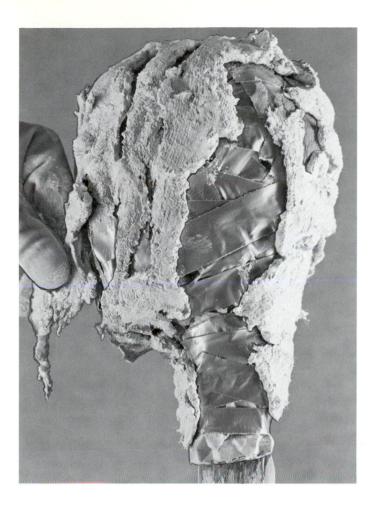

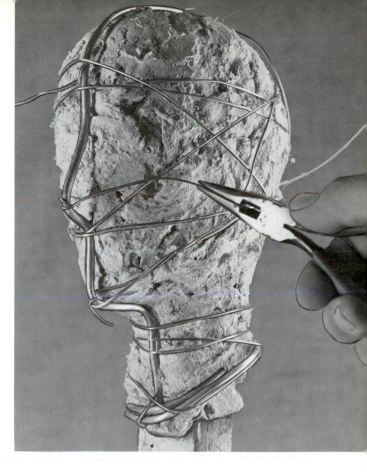

3. Place steel reinforcement over fiber-cement. Nine gauge wire reinforces nose, chin and bottom of neck.

2. Place fiber-cement over core.

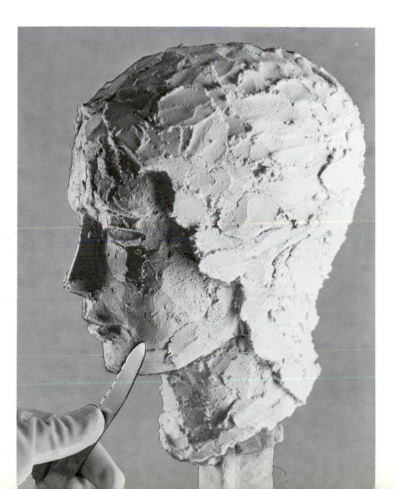

4. Brush on slurry, pack sand-cement into the wires and shape it to block out the features.

Note that if you prefer this type of rough and faceted finish you can stop at this stage.

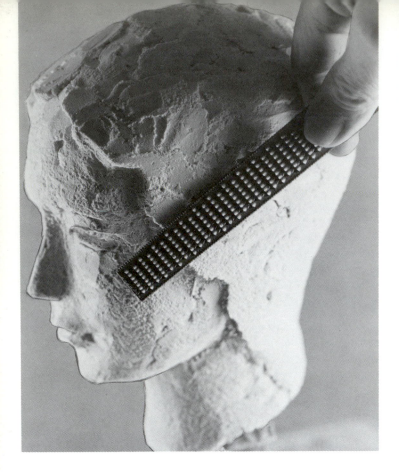

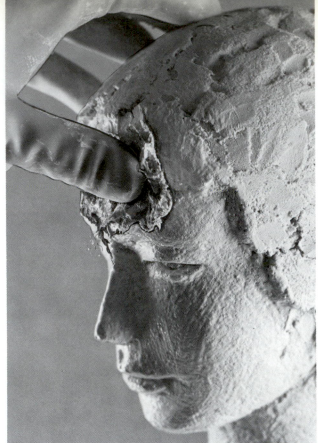

5. As soon as cement sets trim with a dull rasp.

6. Brush on slurry and apply thin layer of fiber-cement.

7. Model the features and other details.

8. Trim the features with small rasps and with a sharp knife carve details as soon as the cement sets firmly.

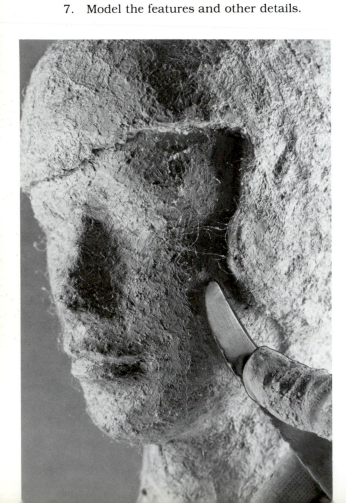

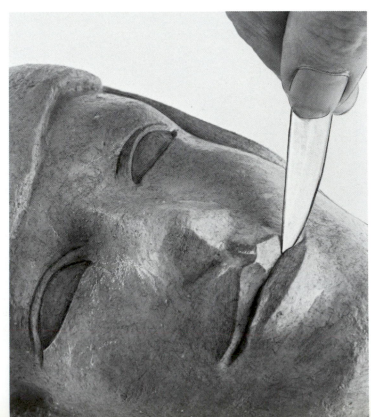

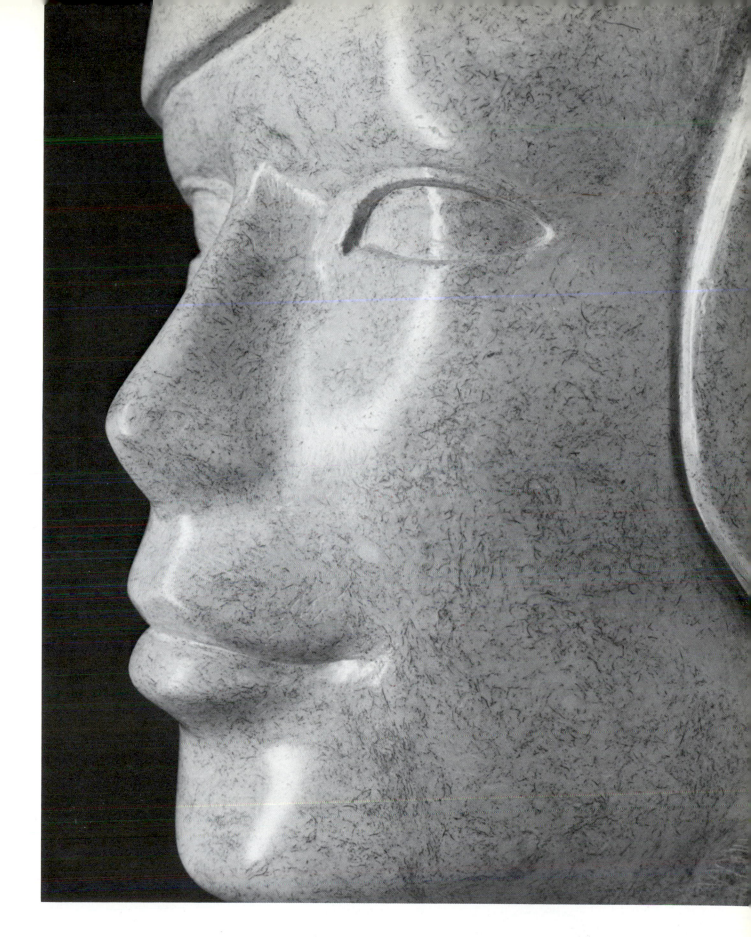

Bronze wool mixed with white cement and acrylic polymer in the final layer was revealed as fine blue lines as the surface was finished with silicon carbide paper. After the cement dried thoroughly it was coated with methyl methacrylate.

Sue, life size.

VII. Sculpting the Four-Legged Figure

A four-legged figure can be built without a base if the legs are strong enough to resist breakage. Any force pushing on a leg creates stresses which are directly proportional to the force multiplied by the distance of that force from the body. This is why long legs break easier and why they usually break where they join the body. But breaking stresses are also inversely proportional to the thickness of the leg. The thicker the leg the smaller the stresses, which is why short, thick legs are stronger than long, thin legs. To build a strong design without a base we keep the legs short, make them thickest where they join the body and let them taper to thin dimensions at their ends. The same consideration applies to the neck which should be thickest where it joins the body. Live animals have legs and neck thickest where they join the body so this principle harmonizes with what we expect to see in these figures.

To be effective the steel reinforcement should follow the general outer contours of the legs, the neck and the body and this steel should lie close to the surface. Bend and shape the nine gauge wire into the general form of the figure as illustrated and then follow the procedures outlined in the sequence of illustrations.

Note that this same principle of reinforcement can be used in a large scale design where steel rods would replace the nine gauge wire. A large figure would be built hollow as a shell design which is discussed in a later chapter.

A four-legged figure with long, thin legs requires a base to prevent breakage of the legs. When all the legs are anchored in a base all four legs act as one structural unit with the breaking stress inversely proportional to the distance between the legs. With the base strength is less dependent upon the thickness of each leg and more dependent upon the distance between them.

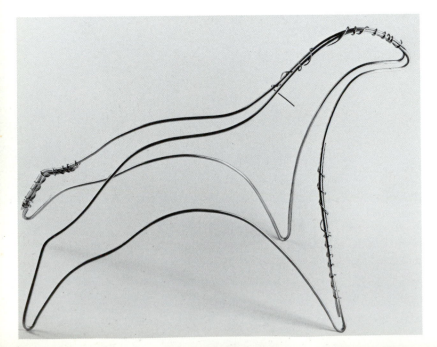

1. To build a short, four-legged figure without a base bend nine gauge wire to the general outer contours of the figure so the legs and neck will be thickest and widest where they join the body. Where the heavy wires overlap bind loosely with small gauge wire.

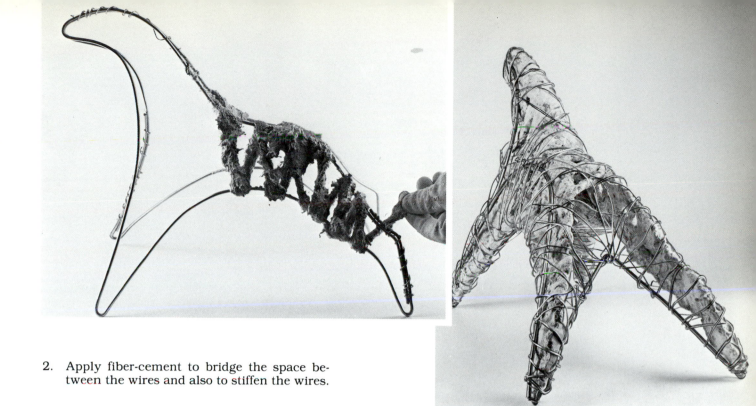

2. Apply fiber-cement to bridge the space between the wires and also to stiffen the wires.

3. Note how additional heavy wires in legs are placed so legs will be thickest where they join the body.

4. Brush on slurry and apply sand-cement.

5. Shape the sand-cement.

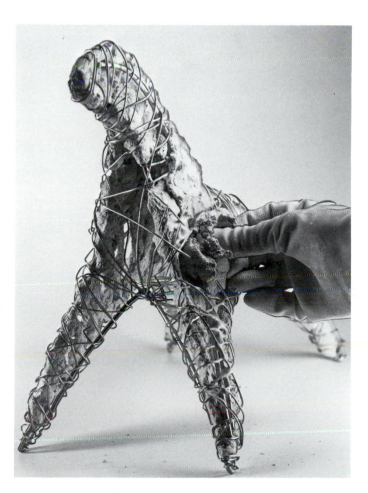

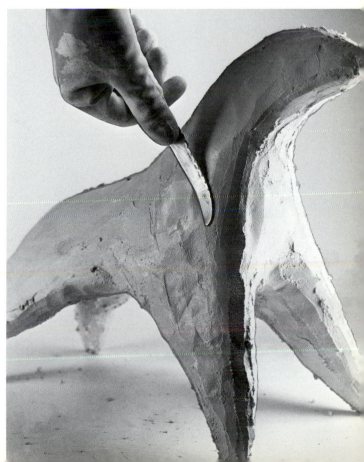

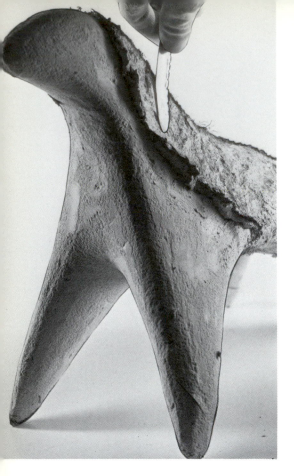

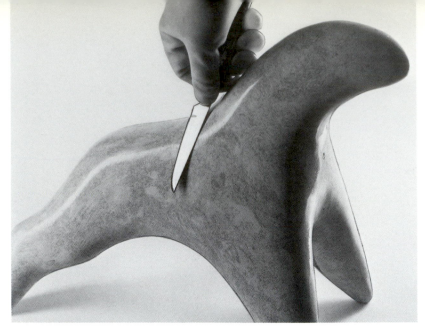

7. When the fiber-cement sets firmly trim with a rasp. As it hardens, finish with silicon carbide paper and burnish with the flat side of a knife blade. After the cement has thoroughly dried coat with methyl methacrylate and buff to a gloss.

6. Trim the sand-cement with a dull rasp, apply slurry and then apply a thin layer of fiber-cement.

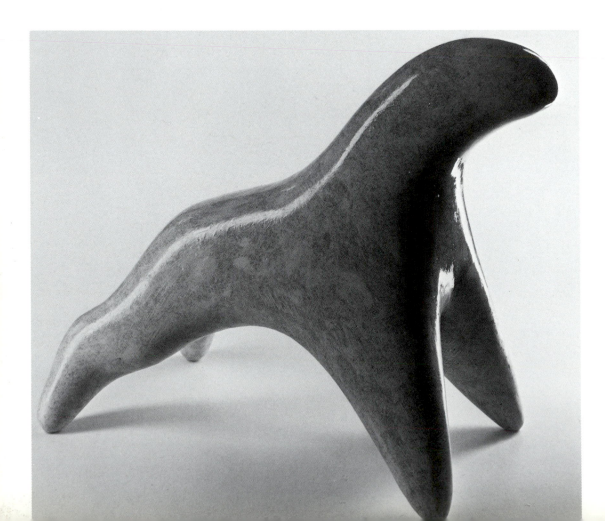

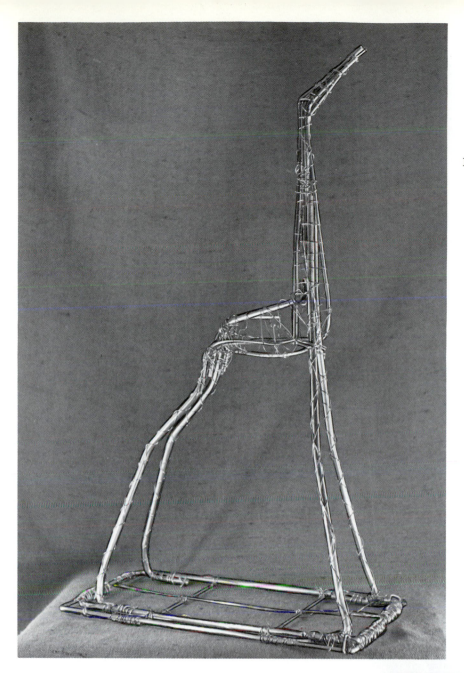

1. To build a long-legged figure bend heavy steel rods (half-inch shown here) to form the legs and anchor these rods in the base and in the body. The rest of the design can be outlined with thinner rods. Wind many turns of small gauge wire around this frame to hold the cement mix. The base can be treated as a flat shell (see next chapter) and reinforced with wire mesh, or reinforced as the rest of the design.

2. After applying sand-cement wind more small gauge wire about the form, apply more sand-cement and shape to the final contour. Apply slurry and fiber-cement and finish as described for the short-legged figure.

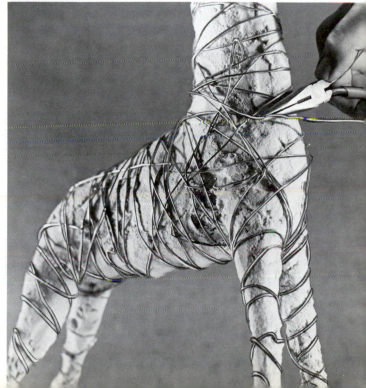

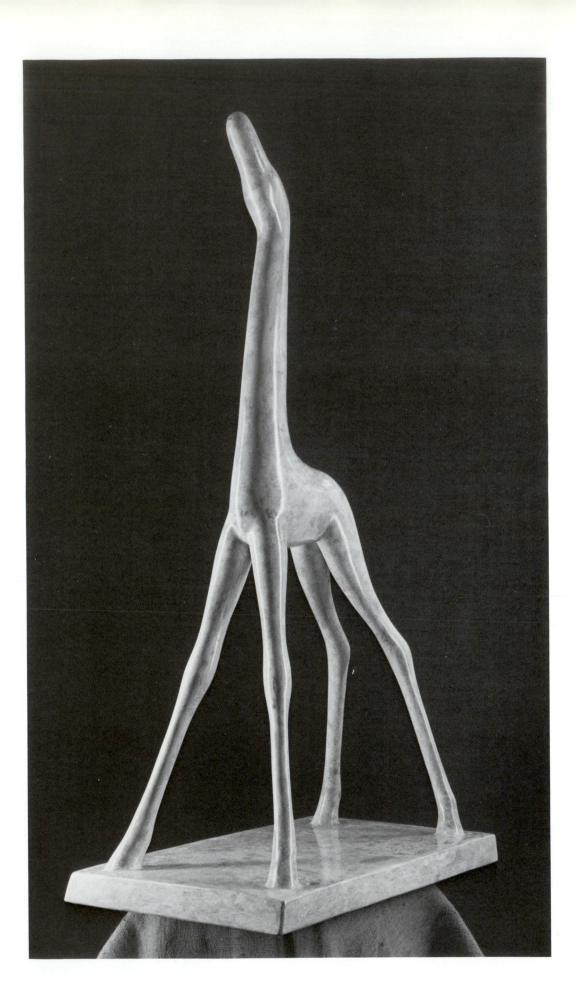

Giraffe, 45 inches (114 centimeters).

VIII. Sculpting the Two-Legged Figure

The two-legged figures described in Chapters 2 and 3 were small enough to require only the windings of small gauge wire reinforcement but a larger figure requires a particular reinforcement pattern.

The ankles are the thinnest part of the legs, they develop the greatest stresses, are usually the first part to break, and have presented a problem throughout the history of figure sculpture. Consider what happens when a tall, two-legged sculpture is moved from one place to another. As the base moves in one direction the inertia in the body of the figure creates a force in the opposite direction and the heavier the figure the greater the force. Stresses develop in the ankles and are directly proportional to the inertia force multiplied by the length of the legs. The longer the legs the greater the stresses and thin ankles develop greater stresses than thick ankles. As moving continues the inertia force reverses itself and a back-and-forth swaying motion develops which can rapidly raise the ankle stresses to breaking proportions. The same stresses develop whenever the sculpture is bumped or a strong wind blows.

When ancient Greek sculptors carved free-standing, two-legged figures in stone they learned how easily exposed ankles can break. Later sculptors used such devices as carved tree trunks or animals attached to the legs to reinforce the ankles. Other sculptors followed their example. Consider the tree trunk carved behind the right leg to reinforce the ankle in Michelangelo's David. The sculptors of pre-Columbian Central America were faced with the same problem. Their monumental sculptures such as the four monumental stone figures at Tula, Mexico illustrate how, instead of attaching tree trunks, the ankles were reinforced by thickening them far out of proportion to the length of the legs.

Unlike stone, cement compounds can be reinforced with steel to make unnecessary such devices as tree trunks or excessive thickness. Place two heavy steel rods in each leg, one rod as close to the front of the ankle as possible and the other as close to the back of the ankle as possible. These rods should be the heaviest you can bend, perhaps half-inch (12 millimeters) or more in diameter. Bend the rods to follow the curvature of the legs and anchor them securely in the base. For effective reinforcement these rods should reach all the way from the base to the torso or higher as shown in the drawing, page 41.

Any linear member such as a leg, arm or neck can suffer bending from its own weight when at rest and more bending whenever the figure is moved or bumped. This bending is seldom enough to notice but very slight bending can produce very large stresses. In bending the greatest stresses develop at the surface. Bend a stick until it breaks and notice that it breaks first at the surface. For this reason place the reinforcing rods as close to the surface as possible and cover them with only enough cement mix to prevent rusting and to develop surface contours.

In bending, stresses develop as a *couple*, that is, tension develops in one side and compression develops in the opposite side of the member. You noticed that the bent stick broke first on the side. You have also noticed that thick sticks do not break as easily as thin sticks. This is because increasing the distance between the compressive and tensile stresses reduces their magnitude. For this reason place the steel rods on the opposite sides of a member as far apart as possible which is the same as saying make each member as thick as is consistent with the design and place the rods as close to the surface as possible. See the drawing.

You may also have noticed that leaning too heavily on a thin stick causes it to bend or buckle. The same buckling can occur in any reinforcing rod under compression. To prevent buckling wind spiral turns of wire around the several rods and place the wires closer together in sections of greatest stress such as the ankles.

The position of the arm affects its resistance to breakage. The straight, reaching out arm is most liable to be struck, and because of its length, will develop the greatest stresses at the shoulder. If both arms are joined at their hands they will be stronger because one arm supports the other. If an arm reaches up above the head it can be strengthened by joining it to the sides of the head. An arm that rests its hand upon the hip is stronger because it is fastened to the body at two places.

The sculptors of antiquity understood the structural value of drapery. They often strengthened a reaching out arm by carving drapery over the shoulder and arm. You can also use drapery or clothing to increase the thickness of any member and place reinforcing rods inside the drapery to brace the member.

Because of their delicacy, their complexity and their expressive value, the hands demand careful treatment. You may possibly place one thin rod through each finger, bend it at the knuckle, wind spiral wires about it and then add cement mix.

The neck is reinforced as any linear member but if additional strength is required the hair can be extended to the shoulders and reinforcing steel placed inside the hair.

The torso is reinforced with rods or heavy wires placed vertically at several places near the surface and extended into the neck, arms and legs. Bind these with several windings of small gauge wire.

A short standing figure may be supported by a one piece base attached to the feet. A taller sculpture requires a base so heavy that a figure with attached base becomes very difficult to move. In this case make the base in two parts with the smaller part attached to the feet and provided with holes for bolting it to the larger part. When moving the sculpture the larger part of the base is moved separately.

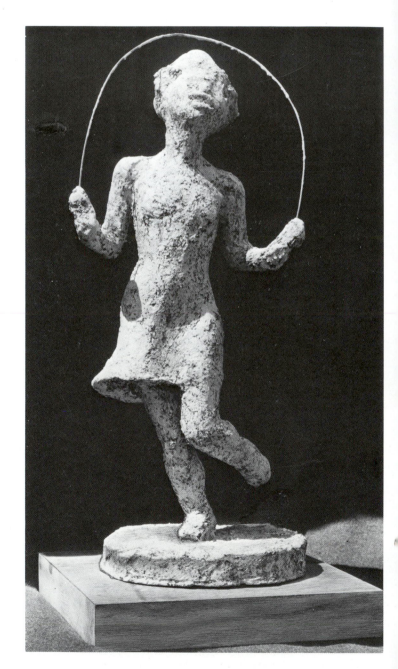

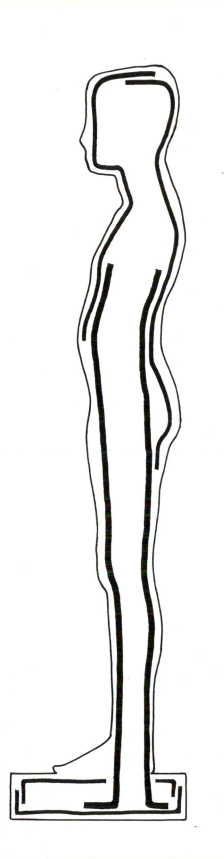

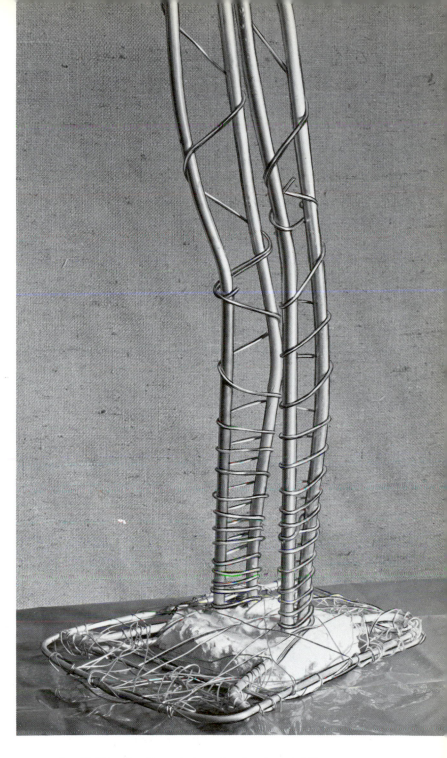

1. Half-inch diameter rods bent to follow outer curvature of legs. One rod close to the front of each leg and one rod close to the back of each leg. Spiral windings of wire to prevent outward buckling of rods. All rods anchored in the base.

Simplified reinforcement pattern for each side of two-legged figure. Heaviest rods in legs and spaced as far apart as possible. Thinner rods in upper part with generous overlap of heavy rods. Spiral windings of wire not shown.

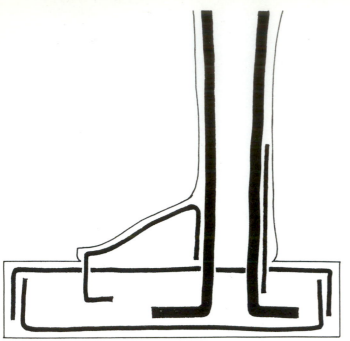

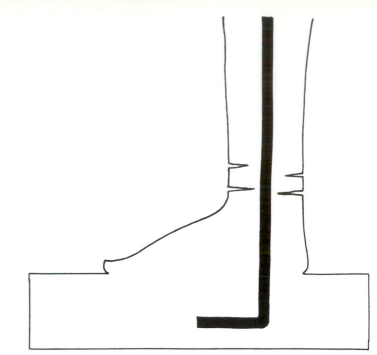

Foot is reinforced with thin rods tied to leg at ankle and anchored in base. Note heavy wire placed to reinforce form of Achilles tendon back of ankle.

WRONG. How not to reinforce ankle and leg. Heavy rod in center of leg allows rupture in outer section where the greatest stress occurs.

2. Before sand-cement sets punch holes in base to receive rods that reinforce the foot.

3. Rods tied to ankle with small gauge wire and anchored in base. Note heavy wires that follow outer contour of foot and large toe.

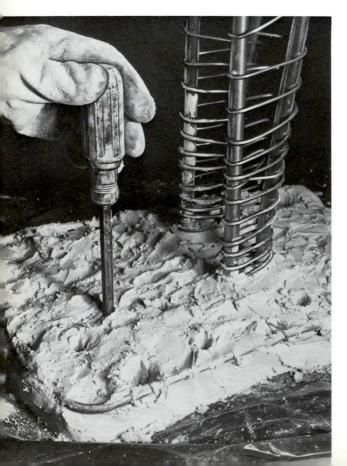

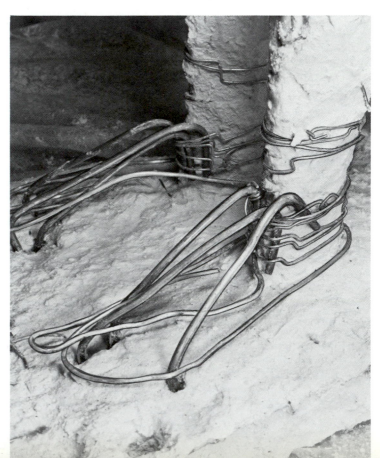

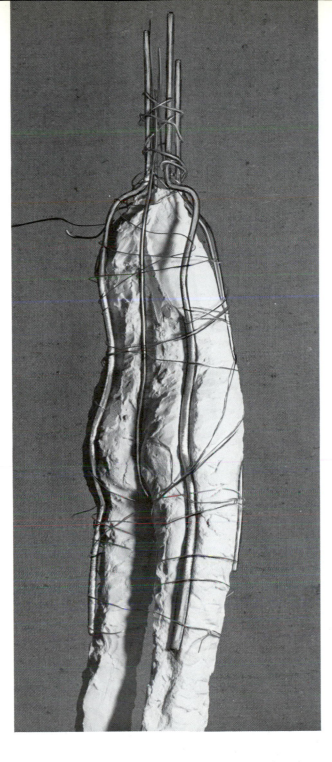

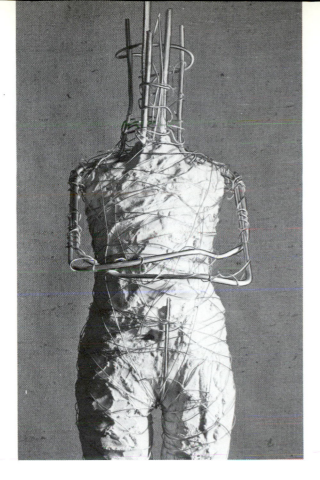

5. Arms are outlined with rods that extend up into the neck and head.

6. After sand-cement is applied to arm rods other rods follow the outer contour of the arms and extend up through the hair and head.

4. Legs and torso built up with sand-cement. Rods in torso placed so they overlap rods in legs and also extend up through the neck and into the head.

Note the heavy wire placed in hollow of back. When rods are covered with sand-cement this wire will remain exposed so that final windings of small gauge wire can pass under this heavy wire as they go around the torso and in this way they will be able to follow the concave contours as well as the convex.

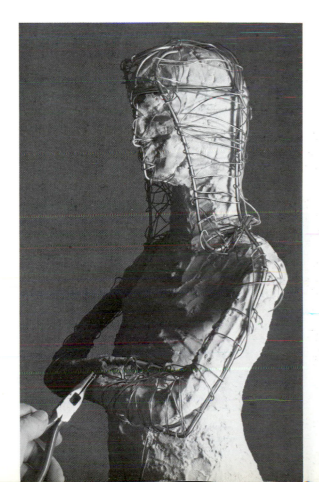

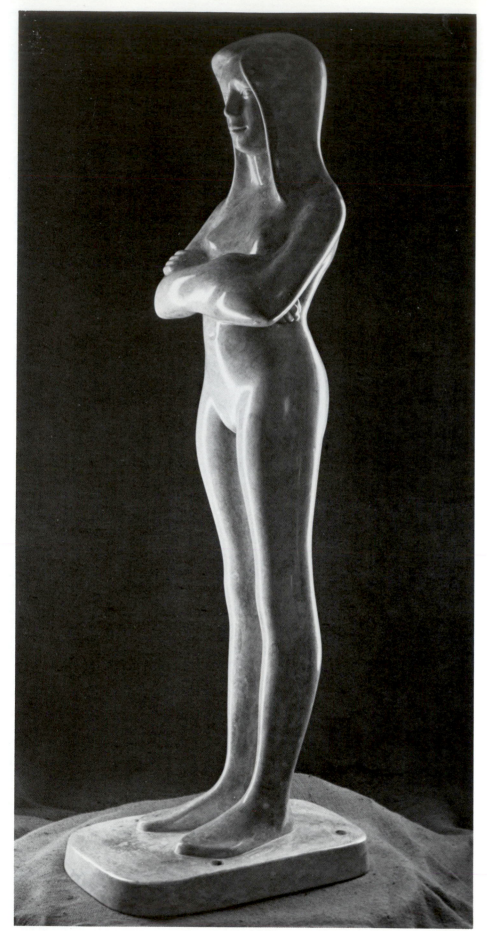

Fibers in white cement with acrylic polymer are used in the final layer which was tool worked to its finished form and then treated with silicon carbide paper as it hardened. After thoroughly drying out it was coated with methyl methacrylate and buffed to a low gloss.

Carrie, 50 inches
(127 centimeters)

Crucifix
seven feet tall
(210 centimeters)

Church of the
Blessed Sacrament,
Albion, Indiana

Several steel rods with spiral windings of wire rein-
force the thin, outstretched arm of the Crucifix. Note
how each finger contains one rod wrapped with wire
and how one rod encircles hole in palm through which
bolt is later passed.

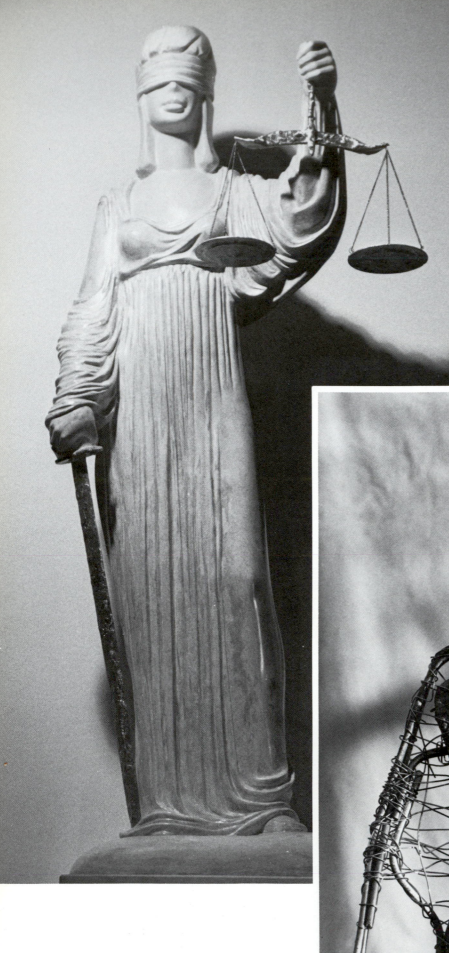

How drapery is used to brace outreaching arm. Steel rods running through drapery support the arm that holds the scales. The arm holding the sword is supported by rods that run through the drapery and brace the arm against the body.

Justice, 40 inches (100 centimeters).

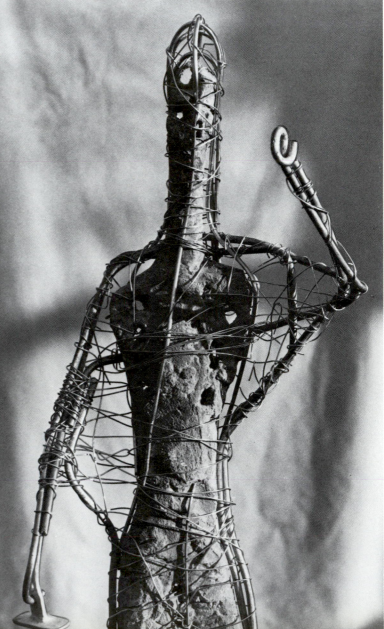

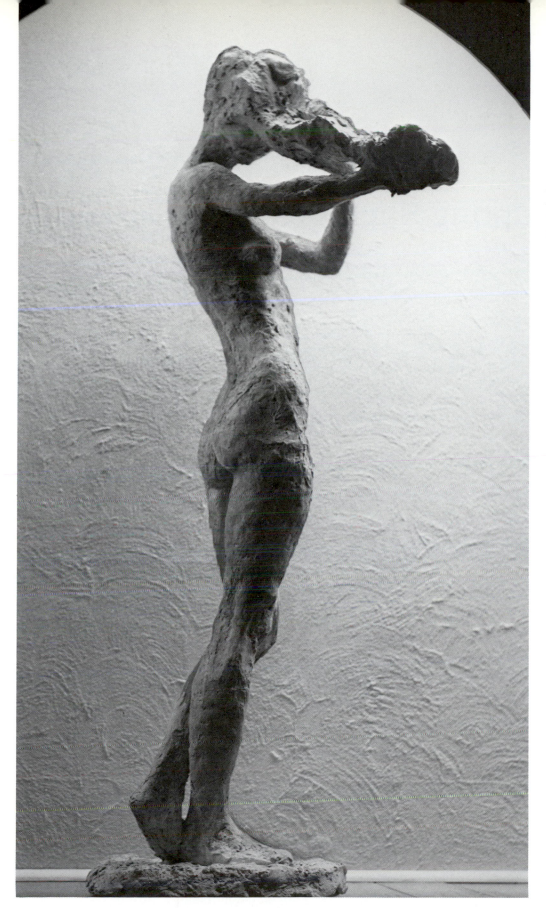

Mary Combing Hair
45 inches
(114 centimeters).
Private Collection.

How hair can support outreaching arms. Steel rods run from the torso through the neck, head and hair to connect with rods in the arms. This forms a triangle of rods similar to that inside the drapery of the figure on the preceding page.

IX. Sculpting Shell Designs

Most of the previously described projects involved linear members, that is, legs, arms, fingers, and necks. Shell designs, by contrast, are sheets that are usually curved with concave and convex surfaces. The shell curvatures discourage bending so that all stresses at any section are either tensile or compressive but not a combination of both as in bending. Since these stresses also spread out uniformly through the shell, their magnitude at any one section is reduced so the shell becomes more structurally efficient than a linear member. Which is why the heavy hen can sit on eggs without breaking them and why you can press an egg shell between your two hands without breaking it — all the stresses are compressive and they are distributed evenly throughout the shell.

All forms and all structures can be described as either linear designs or shell designs or a combination of both. Consider first the bones of the human body. The bones of the arms, legs and ribs are linear designs. The bones of the skull and the hip are shell designs. Note that when a bone must protect a large vital organ such as the brain, it becomes the structurally efficient and lightweight shell design known as the skull. The legs of insects are linear designs but their bodies have outside skeletons which are shell designs. Many insects cast off their outgrown skeletons and in these we can observe the intriguing beauty of these structurally efficient shells. Likewise, the beauty inherent in snail shells and sea shells reminds us how esthetic value is associated with structural efficiency.

Living forms often combine linear and shell designs. Consider how the leaves of trees are shell designs in which linear ribs, built along the veins, serve to stiffen these almost flat leaves.

Find the wing of a butterfly or other flying insect and examine the fine rib structure of linear members which stiffen these almost flat shell designs. Deeply curved shells such as snails do not require ribs as their deep curvature prevents bending but almost flat shells such as butterfly wings require linear members to absorb the bending stresses. Notice also how the linear members on a clam shell enable one shell to fasten to another. Observe how linear members reinforce the edges of shell designs as where the skull is thicker around the edges of the eye opening and where the hip bone has a thick linear ridge along its upper edge.

The hulls of ships are shells that contain ribs both for additional stiffness and to provide fasteners for the internal structures. Huge ferro-cement domes are shell designs with a thickened lower edge, a linear design, that fastens the dome to the wall. In your own shell designs you will rely upon the curvature for stiffness but will add ribs wherever they seem necessary. As you build a structurally efficient shell you also create an esthetically pleasing design.

To build your own shell design you can follow the method of ferro-cement, the intimate combination of steel wires, sand and cement that is used in building cement ship hulls and roof domes. For the distribution of steel wires you may use hardware cloth, expanded metal or poultry netting (also known as chicken wire) which is the easiest to work with and the least expensive.

The chapter describing how to sculpt a head discussed one method of building the head as a hollow shell design. Similar techniques will build other shell designs such as torsos and the bodies of animals. The core can be formed of newspapers, clay, plastic foam or other material.

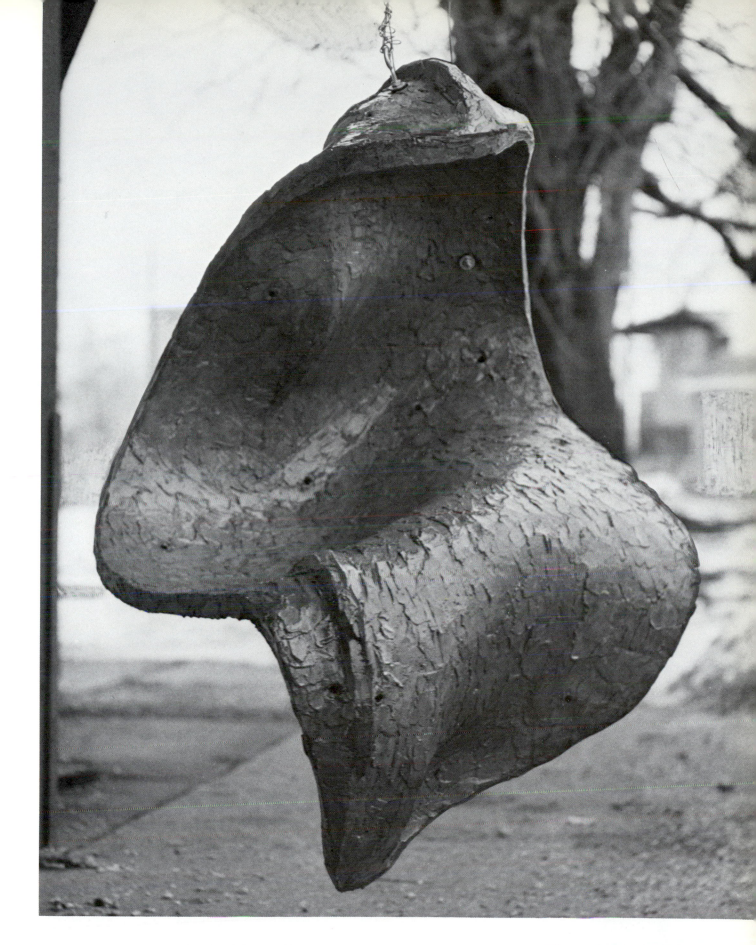

A suspended shell, or pendile, supported by wires tied to eye-bolts passing through the shell. Sand-cement on wire mesh and steel rods, about one-inch thick (2.5 centimeters).

Raindrop, about four feet (122 centimeters).

1. Cut poultry netting into four or more squares about two feet by two feet (60 centimeters square) and tie them loosely together at several places with wire. Arrange the netting so the wires of one layer cross over the holes of the next layer and twist this pile of layers into a curved shell form. Tie a nine gauge wire along each edge and around each corner to stiffen the shape. Bend the cut ends of the wire netting around this heavy wire. Place a steel rod through the design for mounting it.

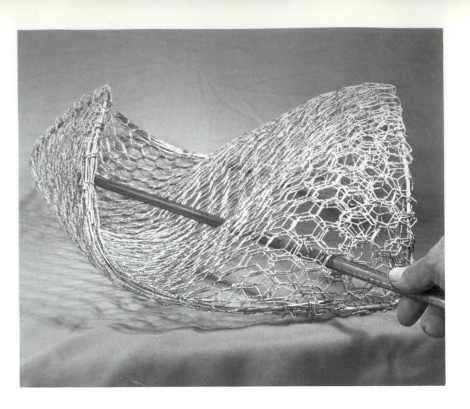

3. Cover with fiber-cement, trim with rasps and finish. A perforated rasp trims in the concave sections if used before the cement hardens.

2. Push sand-cement into the wires. Provide props for support if the fresh mix sags the netting out of shape. The next day, and frequently thereafter, twist the rod to keep it free but leave it in place. Add more mix to fill the open spaces.

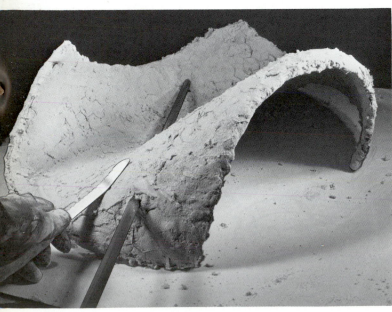

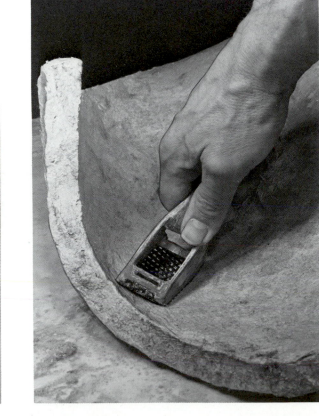

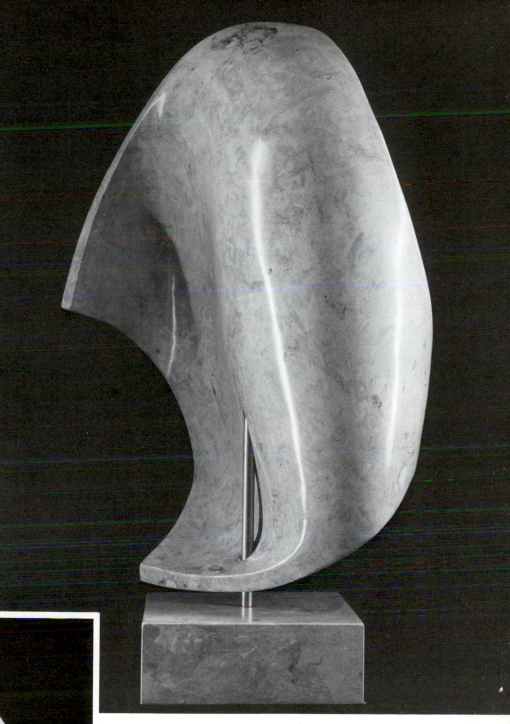

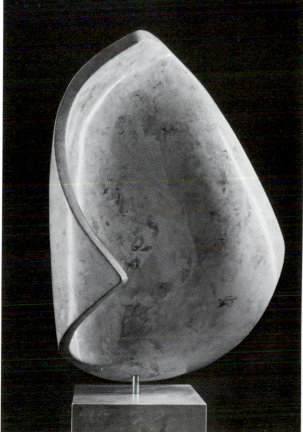

The finished shell has a thickness of about one-half inch (13 millimeters). the supporting rod leaves it free to turn.

Manta Ray, 24 inches (61 centimeters)

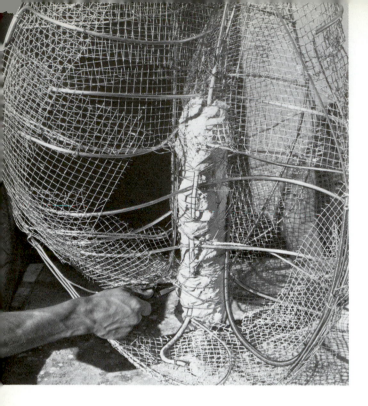

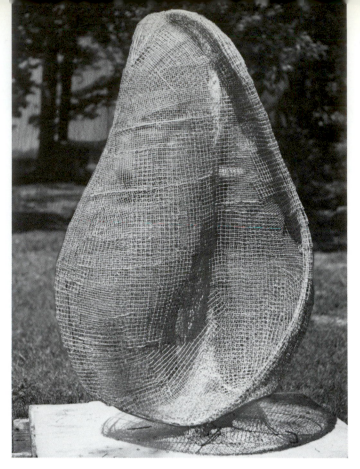

1. Free-to-turn shell built with hardware cloth mesh. See page 86 for description of how to make the turning cylinder upon which the shell is built. Note how curved steel rods are included to give curvature to the hardware cloth and to keep the shape of the curvature when the heavy sand-cement mix is packed into the mesh.

2. Strips of hardware cloth are added to build up a thickness of five or six layers. Small wires tie the layers together loosely.

3. To make certain all wires are covered with cement push the mixture through from one side only until it squeezes out on the other side.

4. When the mixture refuses to squeeze through the mesh tap smartly with a hammer.

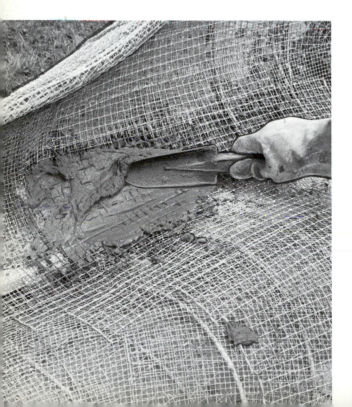

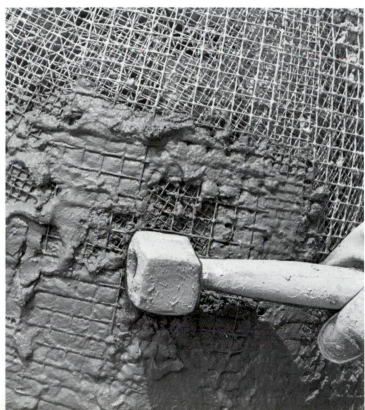

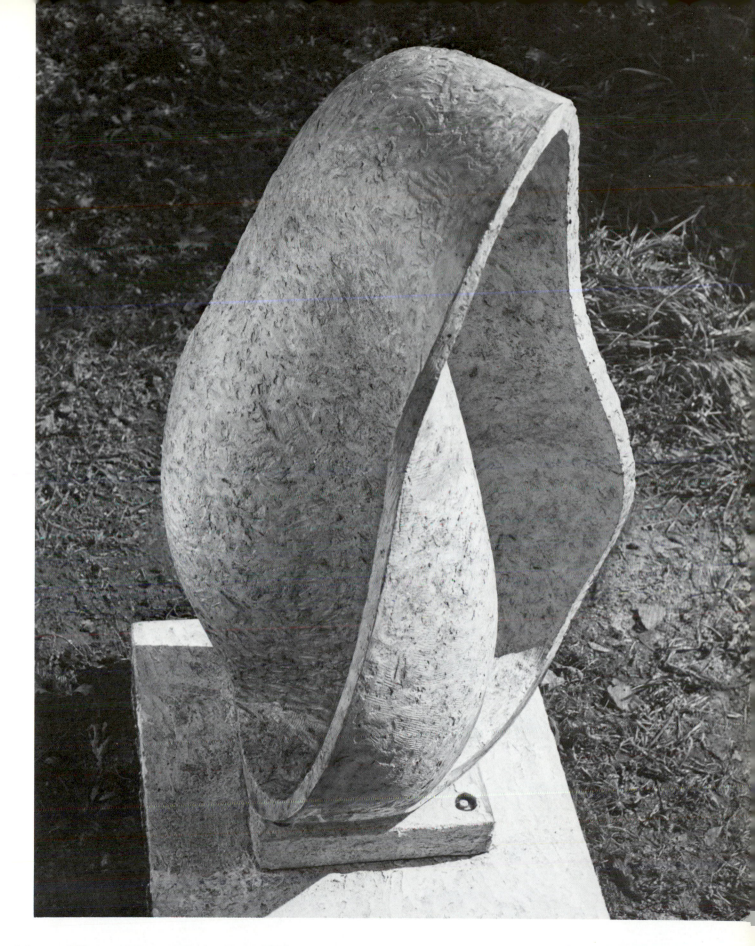

A layer of fiber-cement is applied, trimmed with rasps and then burnished with a rotary wire brush driven by an electric drill. Note bolts in the two part base. The bolt heads will be covered with silicone caulking compound and then the holes filled with sand-cement.

53

Opening Egg, 55 inches (141 centimeters). Private collection.

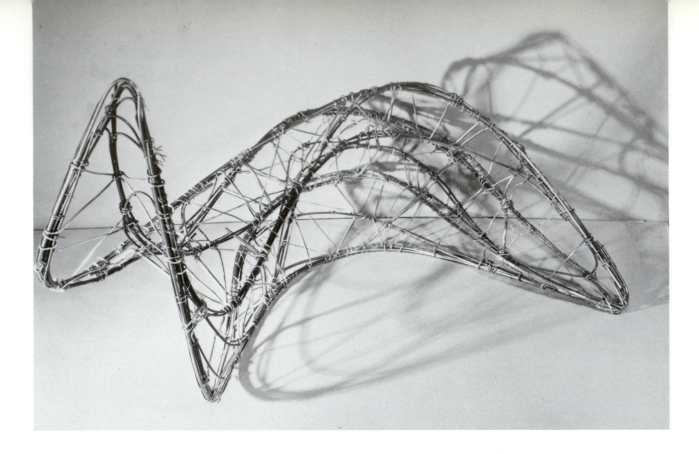

Shell made with expanded metal.
1. Rods and heavy wires are bent to the curvature of the design and tied together loosely with small gauge wires. To make certain all rods are covered with cement a mixture is packed between all rods and wires before the expanded metal is applied.

2. Perforated steel plates are bolted across the rods. Eye bolts are turned through nuts between the plates. When the shell is suspended these plates will carry the load to the rods. Cement mix is packed between these plates before expanded metal is applied.

3. Strips of expanded metal are tied loosely to the cement-packed rods to build up a thickness of three or four layers.

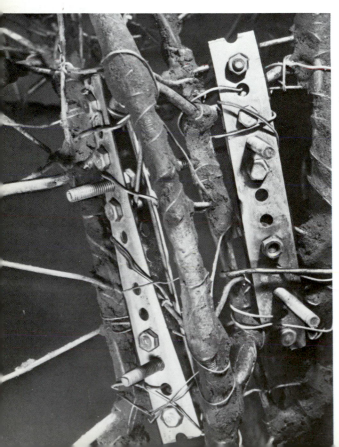

54

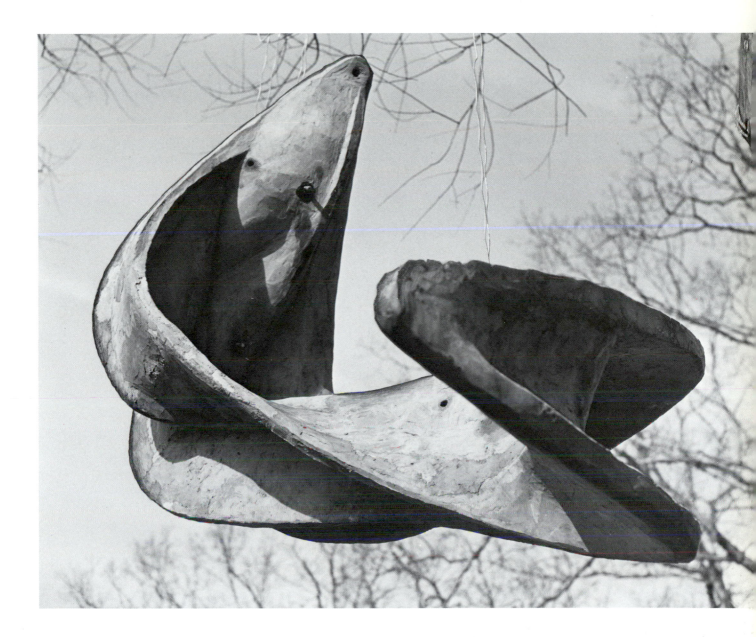

4. A sand-cement mix is packed into the expanded metal mesh and finished with the flat side of a knife blade so that all steel is covered with about one-eighth inch (three millimeters) of cement mix. The eye-bolts are turned loose as soon as the cement has set so they will not bond into place. The eye-bolts are greased and turned back into the nuts inside the shell. Note that the nuts between the plates could have been omitted and the eye-bolts fastened with nuts and washers on both sides of the finished shell.

The finished pendile is suspended from a tree branch by wires tied to the eye-bolts so it can turn gently with the wind.

Flying Seal, about five feet (152 centimeters).

1. A mask, or any other wall-hanging design, can be made in a manner similar to that in the preceding shell designs. Several layers of poultry netting or other mesh are shaped and packed with sand-cement. Before packing with the mix place a heavy wire between the layers of mesh so that loops in this wire protrude from the back of the mask.

2. Picture wire (or a cord) is later tied to these protuding loops so the mask can be hung from a wall hook. Note the threaded rods with the vinyl tips that are turned into nuts that were also placed between the layers of mesh. These threaded rods can be turned in or out so the vinyl tips bear against the wall and prevent the mask itself from touching the wall.

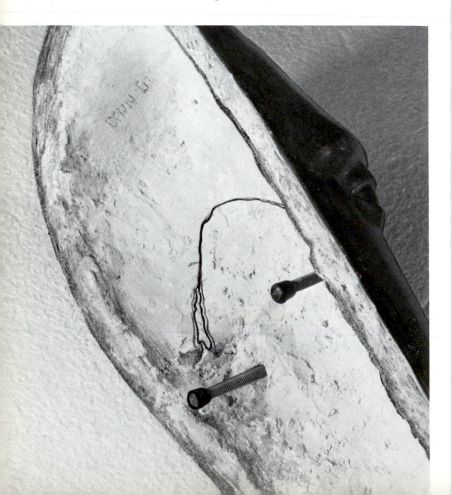

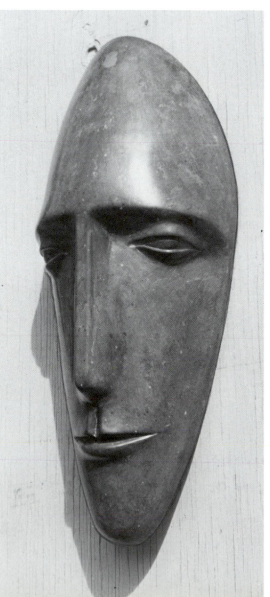

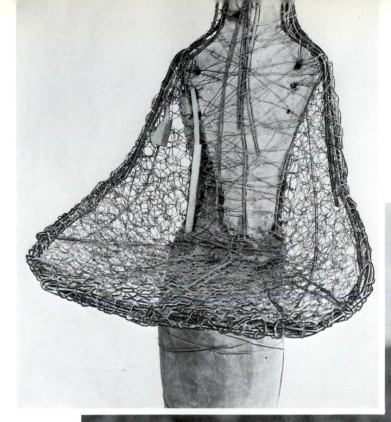

An example of a shell combined with linear members. The water basin is a shell reinforced with wire mesh. The arms of the figure and the rim of the basin are linear members built with steel rods.

57

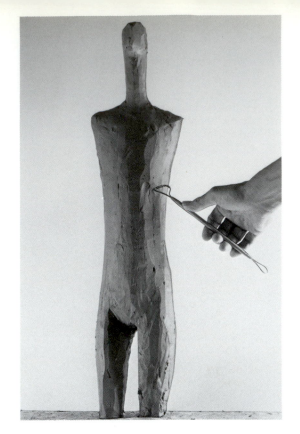

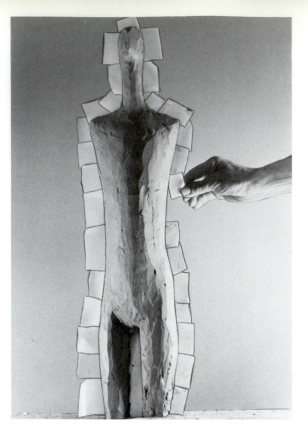

1. To make a hollow torso first build a core of clay on an armature. The clay core will have the size and shape of the hollow space and will be an inch or more smaller on all sides than the finished torso.

2. Push shims into the clay along a line that divides the torso into two parts, front and back.

3. Stretch a very thin sheet of plastic over the clay to make it easier to remove the fiber-cement later.

4. Apply a layer of fiber-cement to completely cover the clay core. Push the fiber-cement up to the shims.

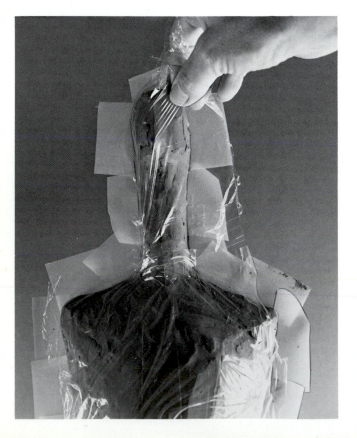

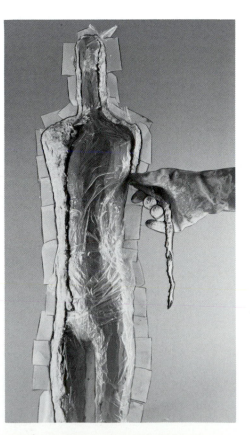

58

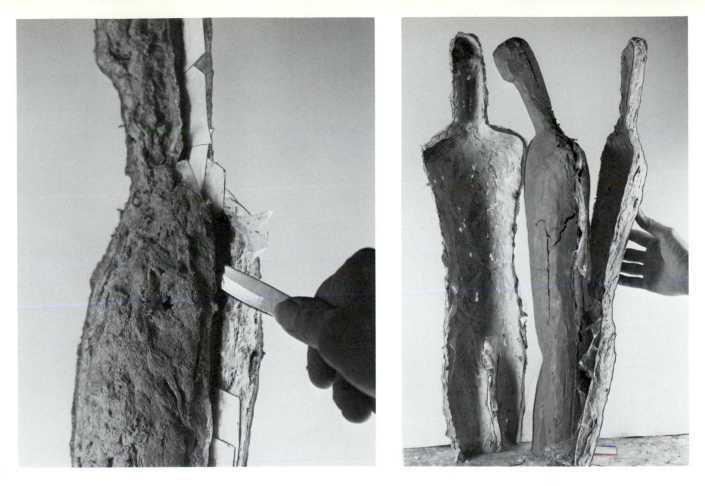

5. After the fiber-cement has hardened for two or more days, or until strong enough, remove the two sections by prying gently with a knife blade along the line of shims. If a section should accidentally break during removal it can be repaired with a fiber-cement patch.

6. Make a paste by mixing cement with a little water, apply to the edges, and reassemble the two sections. Apply fresh fiber cement over the joint left by the shims and let set overnight.

7. Wind many turns of small gauge wire about the hollow form. Bend threaded rods to follow the contours of the form and to extend below the form to later pass through holes in the base. Wire the threaded rods into place but notice that most of the wires pass *under* these rods to prevent the rods from pushing through the fiber-cement and into the hollow space. Brush on slurry and cover all steel with sand-cement.

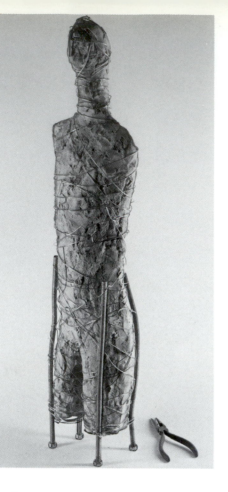 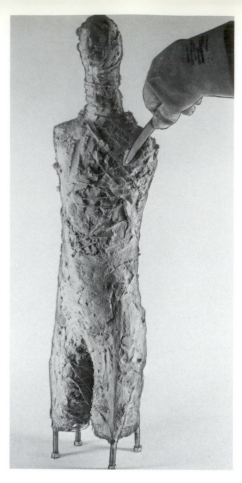

8. Install heavy wires in a vertical direction and also to outline shoulders and hair. Wind small gauge wires about them. Cover with sand-cement and shape to outer contours. Trim with rasp.

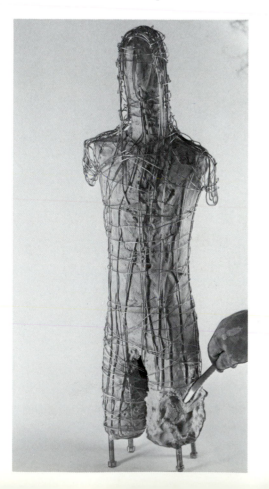

9. To hold the small gauge wires in any concave area, such as the center of the back, anchor a heavy wire with cement at its ends and then run the small gauge wires under it.

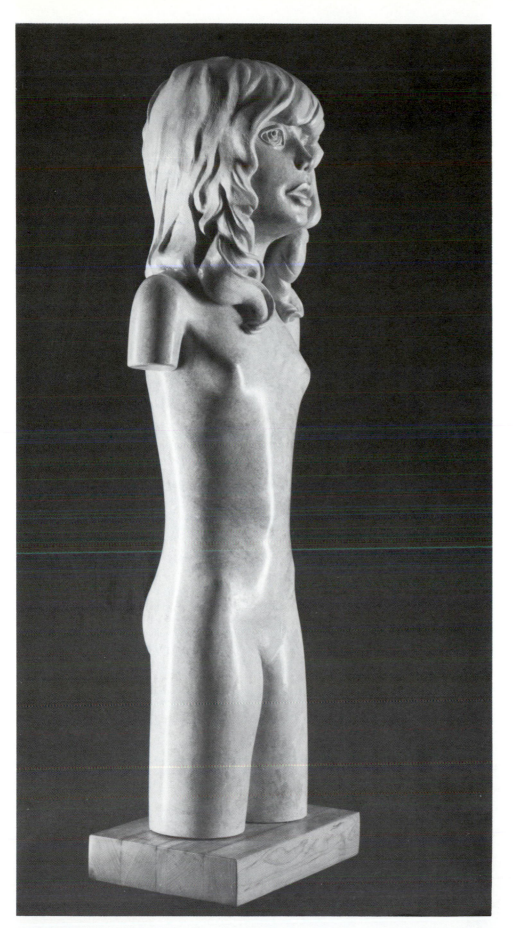

Debbie
35 inches
(89 centimeters)

Bronze wool in white cement with acrylic polymer was used in the final layer which was then trimmed with rasps. When hardened the dry surface was burnished by re-working with dull riffler rasps and dull files. After the cement had thoroughly dried it was coated with methyl methacrylate and buffed.

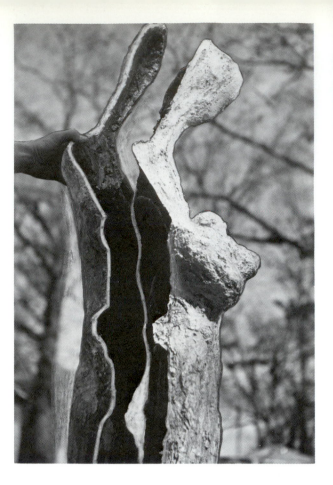

1. Remove fiber-cement sections from clay core.

2. Assemble sections, wind with wire, apply sand-cement and then add heavy steel rods bent to extend into the base. Fasten with wire windings and cover with more sand-cement.

3. Add more steel rods and wires. Apply sand-cement and shape surface details and texture with bent-end knife.

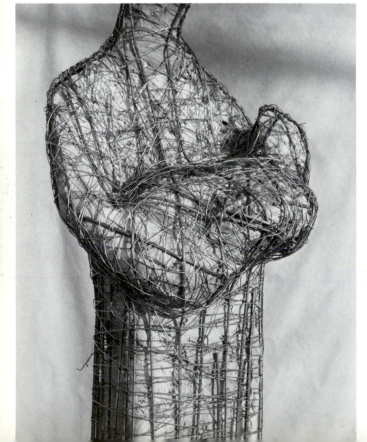

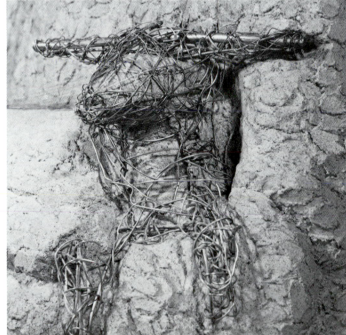

Good Shepherd

six feet (183 centimeters)

Church of the Blessed
Sacrament, Albion, Indiana

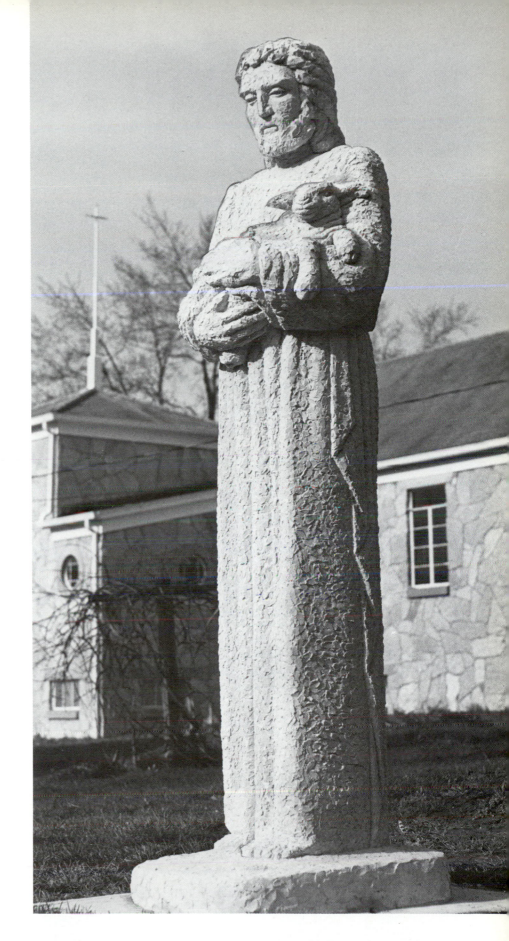

Six foot figure built as hollow shell similar in construction to hollow torso described on pages 58-61. Core of clay modeled on armature, covered with fiber-cement sections which are then removed and reassembled, and the figure built on this hollow form as illustrated on preceding page.

Shell design built on a core of plastic foam.

1. Make block of plastic foam by gluing together several insulation panels obtained at lumber yard.

Outline simplified design and cut with saw.

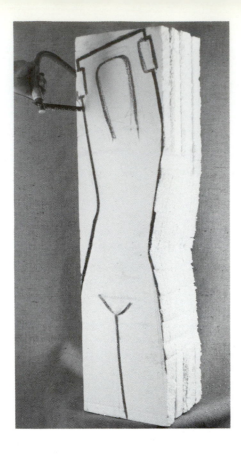

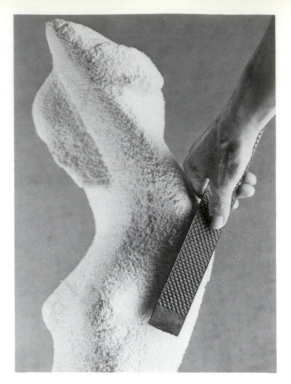

2. Shape the core with a coarse rasp.

3. Apply layer of fiber-cement to the plastic foam core.

4. Place steel reinforcement over the fiber-cement. Note threaded rods that extend below design to later pass through holes in base. Cover all steel with sand-cement and trim with tools.

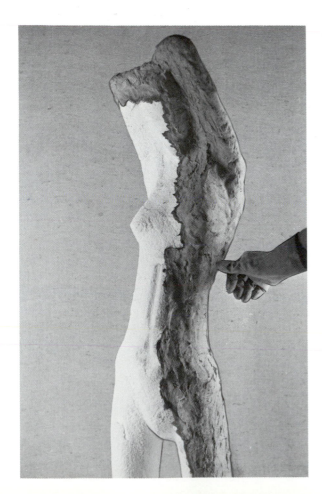

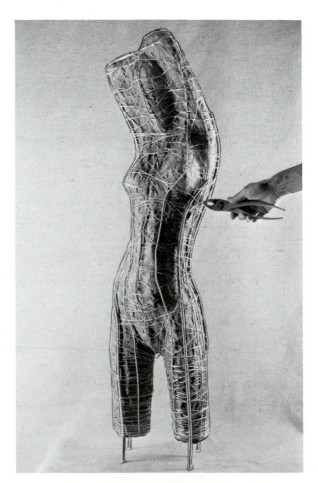

Sandy
53 inches with base
(135 centimeters)

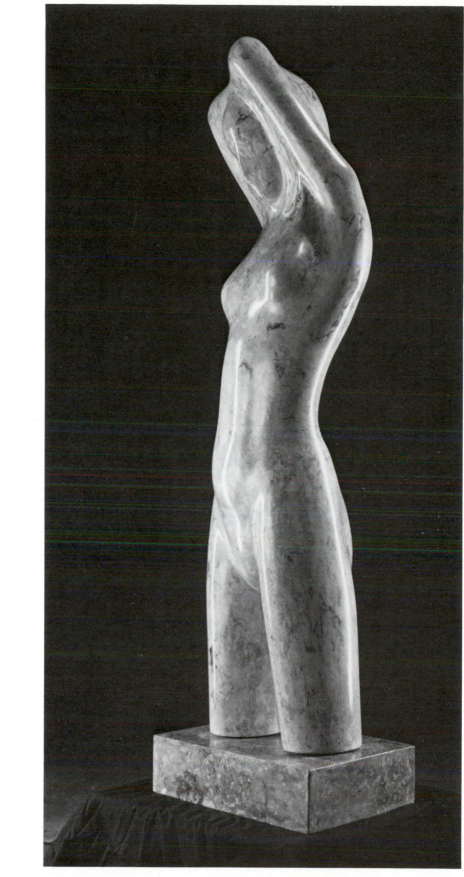

Finished with fiber-
cement, burnished and
waxed.

For illustration of how
base is made, see
pages 76 and 77.

X. Mounting

Stained Glass

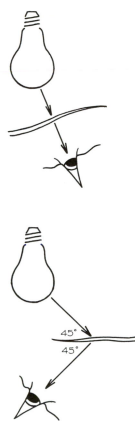

Hold a green leaf so the light from a flourescent or incandescent bulb is reflected from the surface of the leaf to your eye as shown in the first drawing and note the quality of the green color. Then hold the same green leaf so the light passes through the leaf *at an angle* before it reaches your eye, as in the second drawing, and now notice the radically changed quality of the green color. In one case the quality of the color is flat; in the other the quality is radiant and vibrant. In each case the same green leaf is involved so the change in quality must be due to the difference between reflected light and transmitted light. The quality of reflected color is two-dimensional while the quality of transmitted color is three-dimensional.

Now hold the same leaf so the light enters at an angle of 90°, passes straight through the leaf *without bending,* and passes out of the leaf at an angle of 90° before it reaches your eye — as in the third drawing. A flourescent light is recommended for this as it is easy on the eyes. Now move the leaf so the light enters the leaf at about 45° and then passes out of the leaf at another 45° for a complete bend of 90° — as shown in the fourth drawing. You will have noticed that when light passes straight through a transmitting medium the color quality is *cool* and that when the light enters at an angle and leaves at an angle the color quality is *warm.*

Caution: You can observe these same effects by using sunlight but should be careful not to look directly into the sun as that could damage the retina of the eye.

The qualities of transmitted light can frequently be observed in nature. The rich colors in a sunset derive from the bending and separating of the light rays as they pass through the clouds and the dust laden atmosphere. The warm, vibrant colors seen on some birds result from the bending of light rays that pass through parts of the feathers. The markedly different qualities of color in the leaves on a tree depend upon the differing angles at which sunlight passes through them.

These observations of the three-dimensional qualities of transmitted color help us understand the use of stained glass in sculpture. When paint is applied to the surface of sculpture the color of the reflected light remains two-dimensional — it is only colored sculpture. When light passes at an angle through a transmitting medium such as a leaf or stained glass the quality of the color is three-dimensional — it is *sculptured color*. As with stereophonic music, the full quality of color is three-dimensional.

Cement makes it practical to build stained glass sculpture or stained glass windows in which each piece of glass inclines at a different angle to each other piece and therefore transmits a slightly different color quality and increases the range of color variations. It should be noted that the more translucent glass, sometimes known as smoky or opalescent, has more effect on the quality of transmitted color while the more transparent or thinly colored glass has less effect on the quality of the color. Slab glass can be faceted, as described below, to improve its effect on the color quality.

TYPES OF GLASS

Stained sheet glass varies in thickness and the same piece may be very thick at one edge and paper thin at the other. It may have trapped air bubbles or other irregularities and may be transparent, translucent or opalescent. Slab glass, also known as *dalles*, is almost an inch thick (two centimeters) and is cast in slabs usually twelve by eight inches (30 by 20 centimeters). Chunk glass consists of thick, irregular pieces.

CUTTING SHEET GLASS

Always wear eye protection when cutting glass. Clean the glass and oil the wheel of the cutter. Press gently to make a shallow scratch. Bend the glass away from the scratch immediately because the tension created by the scratch relaxes quickly. Complex curves are best cut a small amount at a time. A convex curve can be shaped by cutting off several tangents to the curve. A concave curve can be approached gradually. With a pliers break away a small section of the area inside the concave curve and continue until you reach the desired shape.

CUTTING SLAB GLASS

Slab glass is cut on a chisel-type anvil such as a wide edged mason's chisel. Drill a hole in the end of a heavy log or a heavy timber to hold the handle of the mason's chisel so the edge is up.

The force of the slab on the anvil can send splinters of glass flying in any direction. Full face protection, such as a plastic face shield, is recommended, but at least wear safety goggles.

The first cut divides the slab in half. Clean the glass and with a glass cutter score a fine scratch across the middle on the smooth side of the slab. Put on gloves and grasp the slab firmly with one hand on either end and bring the slab down sharply against the edge of the anvil. The scratch on the slab should be directly over and parallel to the anvil edge so the slab will rupture along an almost straight line. It takes practice to bring the slab down with both force and good alinement.

To cut the smaller pieces use a mason's hammer, a tile hammer or a mosaic hammer. The latter two are available with carbide inserts, work better and last longer than the mason's hammer. With your glass cutter score a fine scratch on the smooth side of the partial slab. Hold the glass on the anvil so the edge of the anvil fits into the scratched line. The anvil and the chisel edge of the hammer should operate something like the two blades on a pair of scissors. The chisel edge of the hammer should pass slightly to the inside of the anvil as you bring it down sharply on the glass. Practice to learn the correct arc and the proper impact.

FACETING SLAB GLASS

Hold the partial slab in one gloved hand or against a heavy wooden support. With a hammer strike along one side of the edge and a chip will fly off. This chip will remind you of a clam shell and will leave a many-faceted depression on one side of the glass to enhance the color quality. Limit facets to one side only and preferably to the rough side. Save the chips. They too can be mounted.

CRACKS, WANTED AND UNWANTED

Size, shape, texture, irregularities, thickness and color all have an effect upon the tendency of glass to crack. Sheet glass cracks more readily than slab glass. Internal irregularities concentrate stresses that result from expansion and contraction caused by temperature changes. Darker colored glass absorbs more heat from the sunlight and expands more than lighter glass. Thick sections of glass absorb more heat and expand more than thinner sections. Large pieces

crack sooner than small pieces. To control cracking from thermal changes limit the size of the glass.

Cement shrinks while hardening and drying to exert pressure on the glass mounted in it and this can crack the glass. Portland cement reacts with glass to produce an expansive compound which can create pressure to crack the glass. These pressures can be avoided by isolating the glass with a flexible silicone sealant. With a knife blade spread the sealant on the edge and a short distance from the edge along both sides of the sheet glass as shown in the drawing. This sealant prevents contact with the cement to prevent chemical reaction and its flexibility absorbs all pressures. Slab glass can be isolated by applying the sealant along the edges of the slab where it would have contacted the cement.

Sheet glass with rim of silicone sealant.

All cracking of stained glass is not objectionable. Cracks refract the light to extend the range of color qualities. But wind driven rain can penetrate cracks and may be undesirable in exterior windows. In any stained glass construction—epoxied, copper foil, lead cames or cement matrix—rain can enter between the glass and its surrounding support. Protection against wind driven rain is accomplished by placing a clear glass window outside of the stained glass. This also protects the stained glass from airborne dirt and smoke deposits which are very difficult to remove.

Any stained glass design requires structural support. When stained glass is mounted in copper foil, lead came or epoxy straight steel members are required at frequent intervals to support a large design. These straight steel members dominate the design and often interfere with its continuity. When stained glass is mounted in a reinforced cement matrix the structural support is provided by the steel which can be bent to follow the contours of the design so that no distracting straight members are required. The primary steel (heavy wires or thin rods) is placed in the protruding part of each rib. Note that this primary steel is **not** placed in line with the pieces of glass. The primary steel in one protruding rib is connected to its mate in the opposite side with small gauge wire to prevent outward spreading of the steel. (See the drawing.)

The design is a combination of transparent glass and protruding opaque ribs. Some ribs protrude more than others and some are wider than others. This variety produces a rib design that enhances the glass design. The ribs are often bathed in colored light from the glass and this adds to the color harmony.

Stainless steel is recommended for all reinforcement to prevent corrosion.

Cross section of ribs supporting slab glass (first drawing) and sheet glass (second drawing). Note how corner of slab glass is exposed so it can bend the light. Note silicone sealant on the edges of the slab glass and around the edges of the sheet glass. Note the pieces of glass set at different angles to enhance the color qualities.

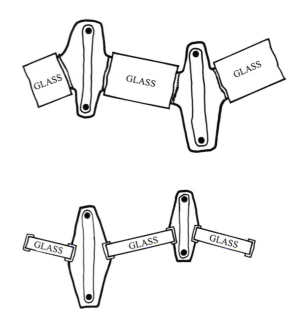

The primary steel in the ribs is shown as solid black circles. Small gauge wires connect the primary steel in each rib to prevent outward spreading.

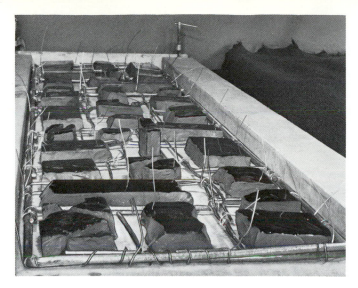

1. Place silicone sealant on the edges of the slab glass. Rest each piece of glass on clay which will hold the glass in position and prevent cement from slipping under the glass. Bend steel rods to frame the design and to run through the first side of each rib. Tie with wires and leave ends of wires reaching up to later tie to rods in second side of ribs.

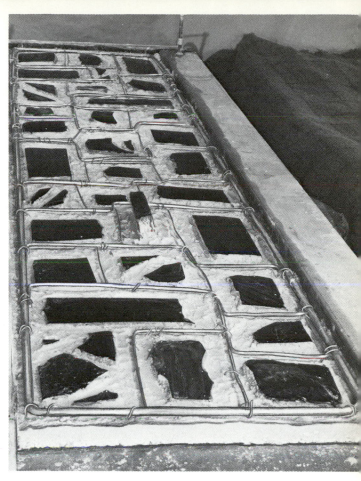

2. Pack sand-cement around steel and between glass. Place steel rods to run through second side of each rib and tie them with the wires left reaching up from rods in first side.

4. Shape each rib with bent-end knife blade.

3. Place many small gauge wires in each rib to absorb shrinkage stresses.

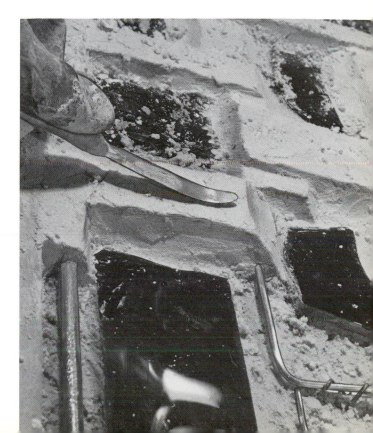

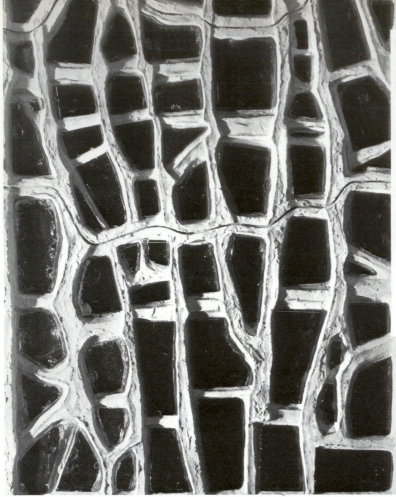

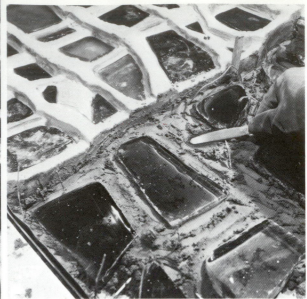

Each section is built against the adjacent section. Steel rods are placed in the ribs along the edge of each section so the joint between sections can follow the curvature of the design.

As the sections are installed silicone caulking compound is placed between them to seal the joint.

The ribs project beyond the glass to form a sculptured linear design of various depths in the manner of relief.

Light passing through the glass bathes the sides of the ribs in color.

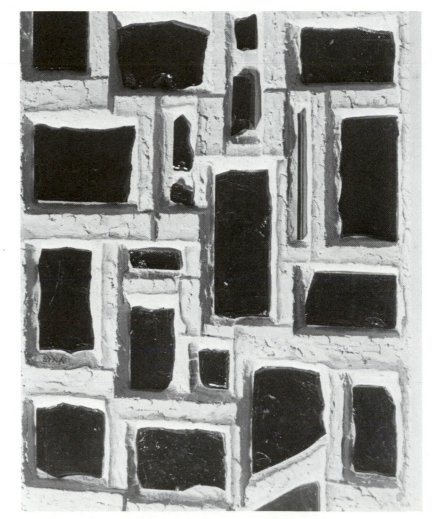

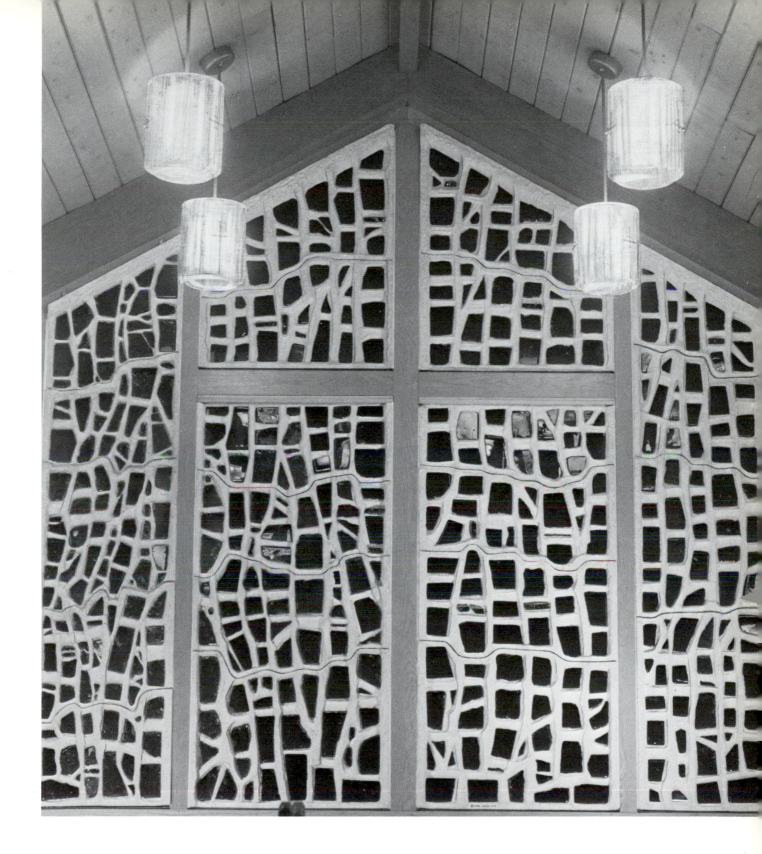

The ribs between the pieces of slab glass form a linear design that compliments the stained glass design and becomes particularly prominent at night when the interior lights illuminate the pattern of lines.

St. Patrick's Church, Ligonier, Indiana.

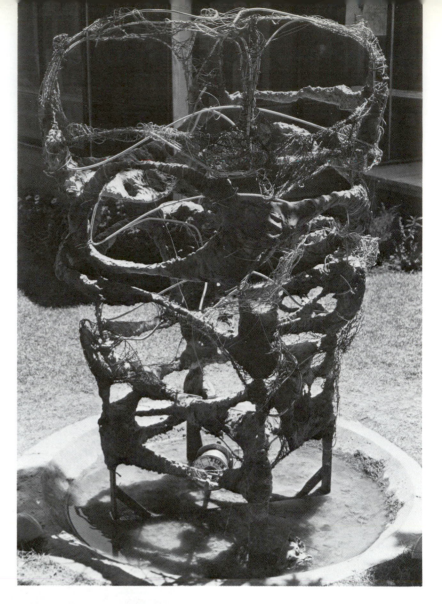

1. A large sculpture built in four sections so it can be taken apart for moving. Threaded rods from one section extend upward and are encircled by rods from the section above it. Small wooden plugs keep the vertical rod centered in the encircling rod. Sand-cement packed into the wire structure.

2. Faceted slab glass mounted on the linear members that cross the interior of the design. Ribs are then built over and around each piece of glass similar to those in the stained glass window (pages 69-70).

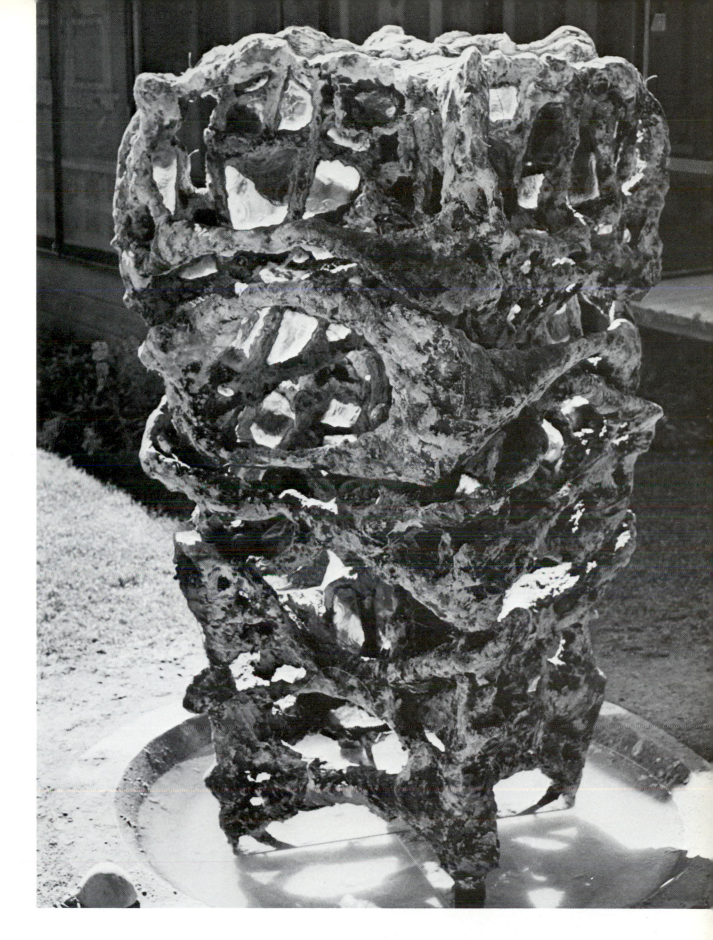

Faceted slab glass pieces are mounted in the interior of the open web design. Each piece of glass is set at a different angle so each piece will offer a slightly different color quality.

Big Rock Candy Mountain, seven feet (210 centimeters).

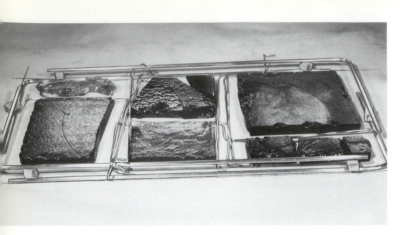

1. Building a stained glass shell design in sections to be assembled at the site. Stained slab glass pieces are cut and arranged for a section. Two steel rods are placed near each edge. Two or more nine gauge wires reinforce the ribs between the glass. This steel will enable the section to withstand the stress of shipping and assembling as well as to reinforce the finished design.

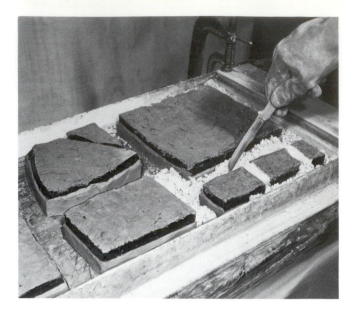

2. The glass is placed in a frame made of steel angles and lumber — squared and clamped. Clay is placed on the sides of the slab glass to protect it from the cement. The thicker layer of clay on the bottom of the glass serves to maintain its distance from the bottom of the frame and determines how far the ribs will protrude.

Silicone caulking compound was applied to the edges of the glass where they will bear against the cement mix. The silicone prevents contact between the glass and cement. The silicone remains flexible and allows the glass to expand more than the cement ribs as the temperature changes.

Cement mix is packed around the glass.

3. Steel rods and wires are pressed into the cement mix. Spacers (small blocks of hardened sand-cement) are placed under the steel to maintain uniform distance between the steel and the outer edge of the rib. Other spacers between the rods maintain uniform distance between them.

Since the cement mix is very stiff the steel is usually forced into place with a small hammer. Note how some wire ends are shaped into hooks at the edges of the frame. These hooks will later be bent out to fasten to the half-inch vertical rods (see photo 6 on next page).

4. After all steel is placed the ribs are modeled to cover, and protect, the steel.

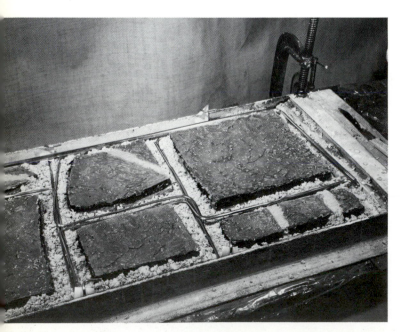

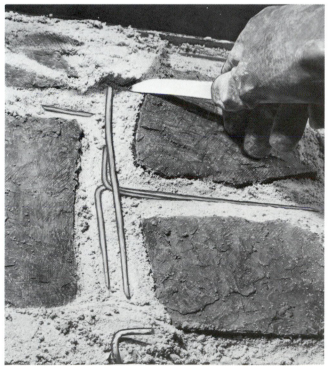

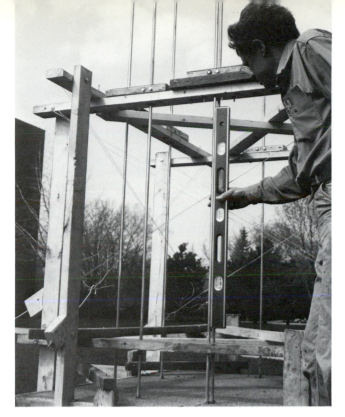

7. The finished shell design is assembled from 35 sections. The convex side faces south so the sun will penetrate some of the glass at any time of the day.

The sculpture is designed to resist a wind force of 30 pounds per square foot. The maximum area exposed to the wind was multiplied by 30 pounds to obtain the total wind force. The overturning moment, or couple, was obtained by multiplying this total wind force by the distance of the centroid of the area above the base. The vertical half-inch rods were then spaced to provide a resisting moment, or couple, three times that of the overturning moment (see diagram, page 102).

Color Concerto, eleven feet (335 centimeters) Purdue University, Hammond, Indiana

5. A template frame is fastened to the form for the concrete foundation. The template spaces the half-inch steel rods and holds them vertical while the concrete is placed for the foundation. The rods are anchored in the foundation and their verticality is checked with a level. Note the diagonal wires that can be tightened to square the template.

6. The sections are fastened to the vertical steel rods with the wire hooks (see photo 3 on preceding page). A cement mixture is placed in each joint. Note how two half-inch rods are placed at the end section to stiffen the edge of the sculpture.
 A quarter-inch rod is placed in each horizontal joint and tied to each vertical rod to provide horizontal reinforcement. A groove in the top of the section accomodates the horizontal rod.

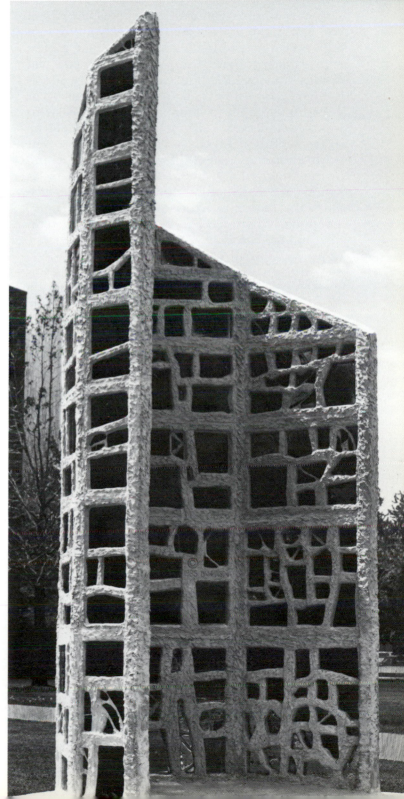

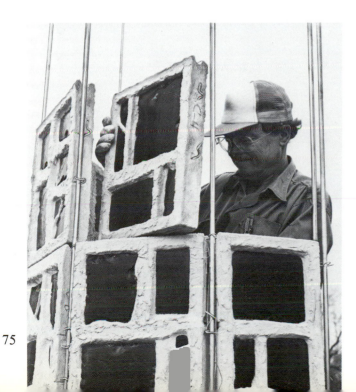

XI. Making the Base

Most sculpture wants an attractive base which you can make with cement and can finish to a high polish or a rough texture. To make a base with square corners and parallel sides you will need a mold which you can build of two-inch lumber, actually an inch and one-half thick (3 or 4 centimeters) and four threaded rods with washers and nuts. All mold lumber should be treated with several coats of heavy oil to prevent warping and to prevent the cement from sticking to the wood. Each piece of lumber that butts against another should be cut as square as possible as this determines the squareness of the base. The mold illustrated can be adapted for several different base sizes.

The base should be left in the mold for two days to give the cement enough strength for safe removal. Wet the base thoroughly as soon as you remove the mold. Keep it wet while trimming the base with files and abrasive paper. Several shallow holes will be found in the surface and these can be filled and refinished as described in Chapter 4. The edges and corners can be filed off at 45 degrees to discourage accidental breakage at a later time.

1. The base will be made upside down in this mold so the piece for the bottom of the mold is cut the same size as the top of the base. This base will have four holes in it to receive four threaded rods from the sculpture so four holes are drilled and wooden dowels inserted. All corners are checked for square.

To make a base of a different size use different bottom and side pieces.

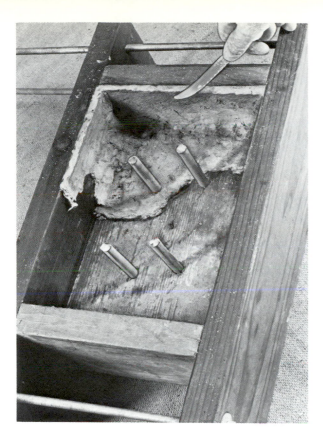

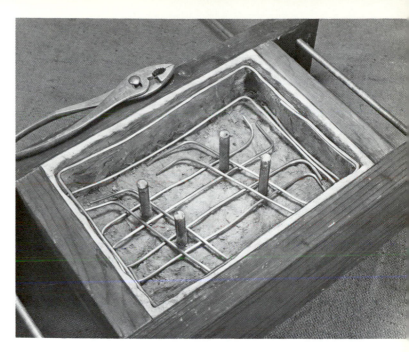

3. Place steel reinforcement so it will be close to surface of base.

2. Pack a thin layer of fiber-cement on all five sides of the mold and push it firmly in place to remove air pockets.

5. Trim sand-cement level with mold and remove dowels as cement sets. Note cavity left in central area and washers placed to later bear against nuts turned on threaded rods from sculpture. See page 65 for illustration of torso mounted on the base.

4. Brush on slurry being careful to get it under all wires and then fill with sand-cement.

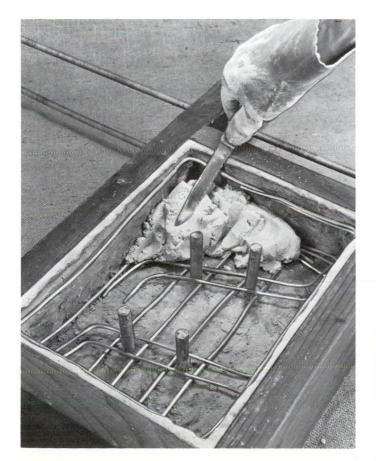

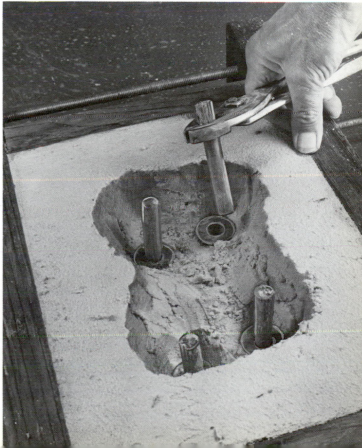

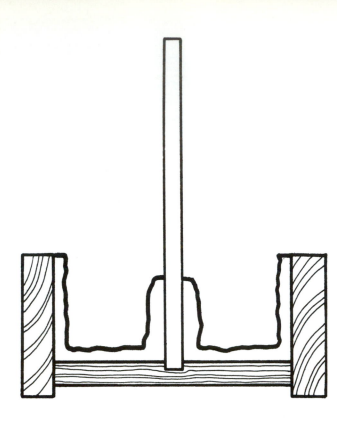

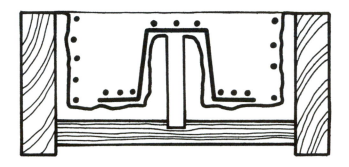

1. Making a base with a center support free to turn. Place mold horizontal. Position the steel rod in shallow hole in bottom of mold and support it to remain vertical or perpendicular to bottom of mold. Line the mold with a thin layer of fiber-cement around the vertical rod. As soon as cement sets firmly but before it hardens twist the rod and remove it while being careful not to break the mound.

2. Bend a strip of steel to fit snugly over the mound. Place heavy steel wires as shown by the black dots. Brush in slurry and fill the mold with sand-cement. Level mix even with edges of mold.

3. After two days remove mold and turn the base over. Insert steel rod in the hole so it rests against the steel strip. *Do not* place sculpture on rod until cement is strong enough to support the weight.

 Here the support rod is located at the center but could have been placed off-center as illustrated on page 80. A base for a head needs the support at one side and would use a square bar to prevent rotation of the head as shown on page 81.

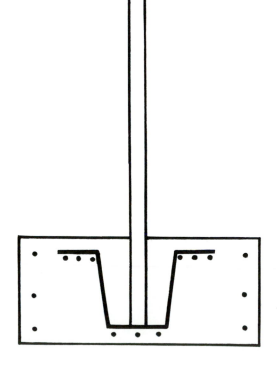

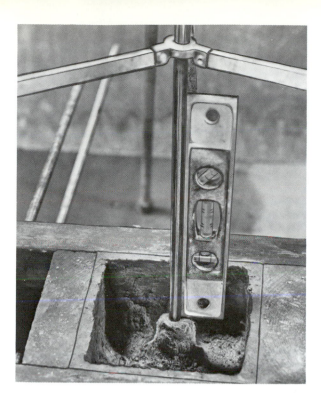

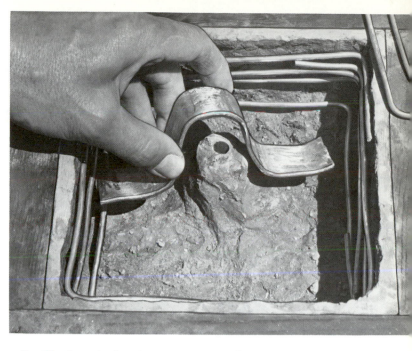

2. Placing steel strip over mound after removing rod.

1. Mold with layer of fiber-cement and mound built around steel rod. Small spirit level used to make certain mold is horizontal and rod is vertical.

4. Remove mold, turn base over, place on horizontal surface, insert rod and check for vertical. If rod is not vertical trim bottom of base as needed.

3. Place steel reinforcement before filling with sand-cement. In a larger base for a heavy sculpture two strips of steel would be placed to cross each other.

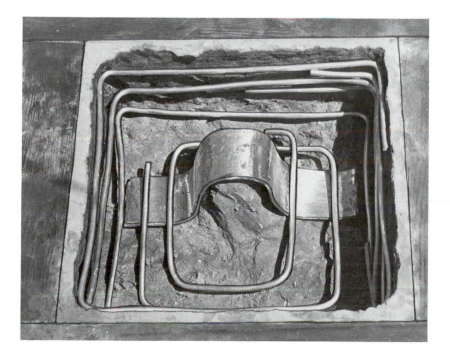

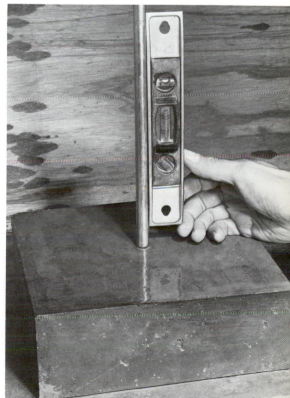

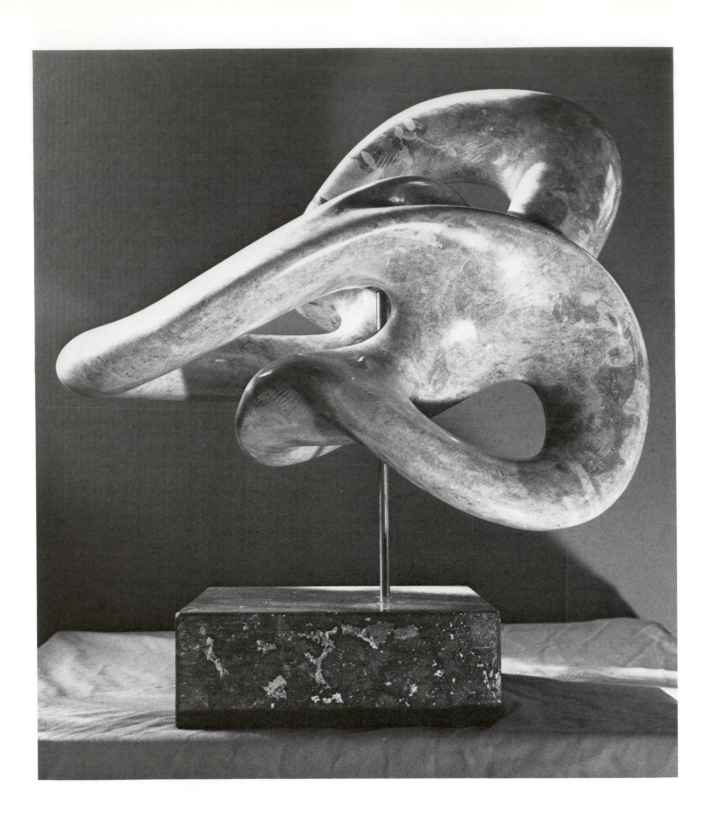

Free-to-turn sculpture with support rod placed off-center of base.

Note the shallow holes in the surface of base due to air pockets between the mold surface and the fiber-cement layer. In this base the holes were left without filling to add a textural element.

Continuous Cobra, about eighteen inches (45 centimeters).

A two part base is often used with a sculptured head. The smaller, upper part relates to the neck while the lower part provides stability.

2. The U-shaped bar fits inside the hollow head and bears against the top of the hollow space as well as against both front and back of the hollow neck.

1. The two parts of this base are joined with short steel rods. Holes for these rods are drilled with a masonry bit. A rubber pad provides a thin cushion between the two parts.

A U-shaped steel bar with a rectangular cross-section is located near the front of the upper part. The bar extends upward to support the head. The hole for this bar is made as illustrated on pages 78-79.

3. The face was modeled with fiber-cement and then finished with riffler rasps. The hair was modeled with neat cement and textured with a bent knife blade as it was applied. The texture left by the knife blade follows the curvature of the curls.

Miriam, life size.

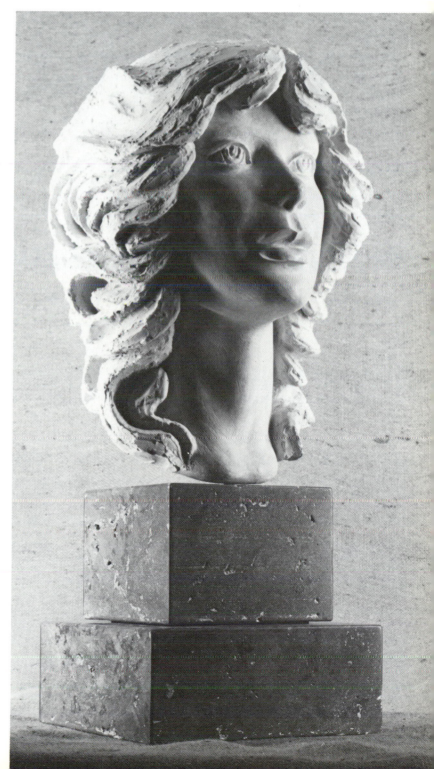

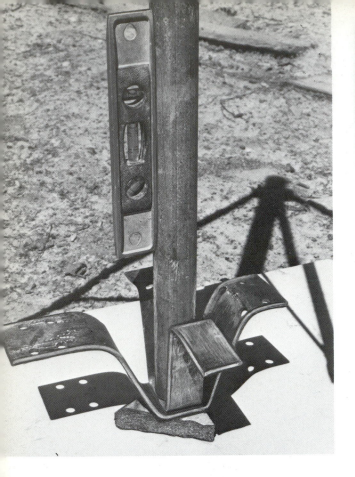

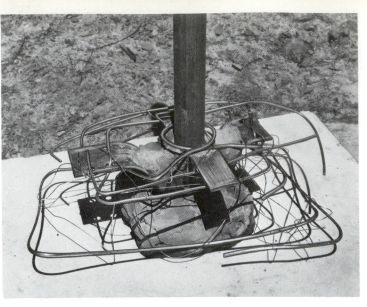

2. Sand-cement is packed around plates to hold them in place and steel wires are placed to reinforce base. Note ring of wire around pipe to reinforce this critical area.

Making a base without a mold.

1. Since this base will support a heavy sculpture a thick pipe is used and two thick steel plates are bent to fit under the pipe. The upper flanges of the plates will be near the top of the base. The pipe is filled with sand-cement to prevent corrosion inside and to stiffen the pipe. Note the piece of stone under the plates to keep them above the bottom surface of the base.

3. Four short pipes placed near corners of base so it can be bolted to a foundation. Note how the heavy wires will lie close to the edges of the base.

4. Add sand-cement and shape to final form.

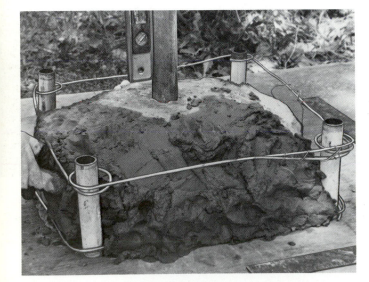

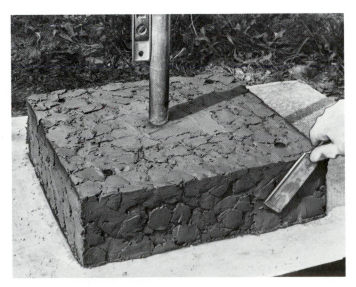

Nymph with Bath
five feet
(150 centimeters)

Private collection

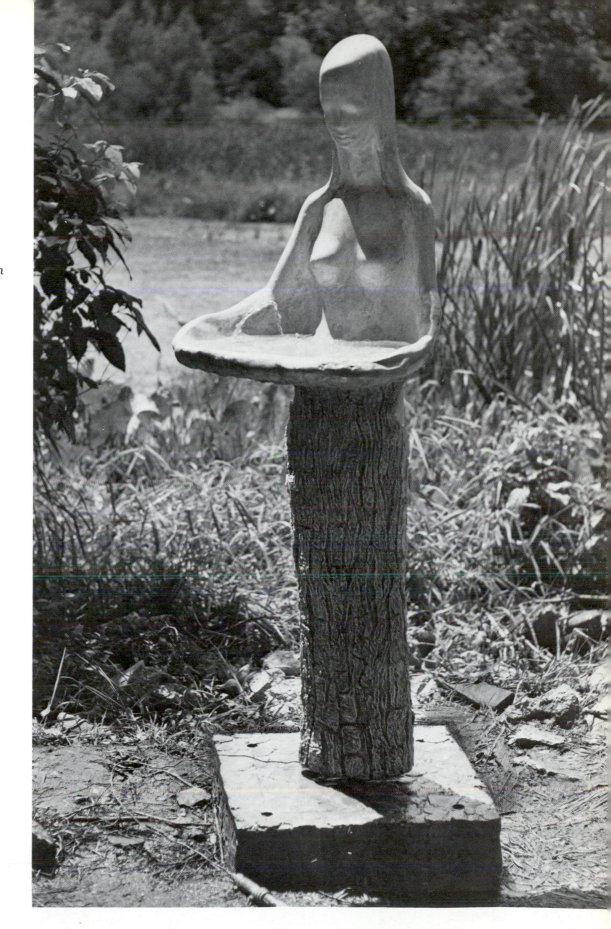

Sculpture mounted on the pipe above the base is free to turn so protected bird bath can face north in summer and south in winter. Jet of water from tiny orifice in copper tubing causes the water in the basin to rise in an arc to attract birds. Copper tubing runs through plastic tube inside sculpture, out bottom, and connects to hose.

XII. Free-to-Turn Designs

The previous chapter described a base with a removable support rod or pipe. Building the sculpture on this rod or pipe will make it free-to-turn. You can wind a heavy wire loosely around the rod and cross it over the top of the rod so steel will bear against steel as shown in the first photo below. Another method is to crimp a steel strip, preferably stainless, over the rod as shown in the second photo below. With either method add a cement mix and then apply more wires as shown in the third photo below. Since cement contracts upon setting turn the rod loose and remove it as soon as the cement sets firmly or it may not come out. Re-insert the rod and continue adding more mix and wires to develop the form as shown in the fourth photo, right. Wait until both base and sculpture are finished before cutting rod to its final length. Apply a drop of oil to keep the rod free.

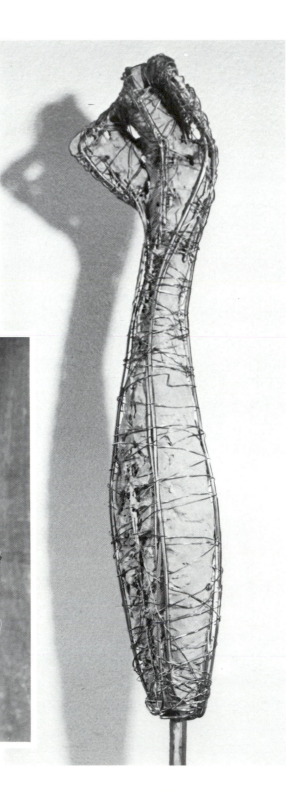

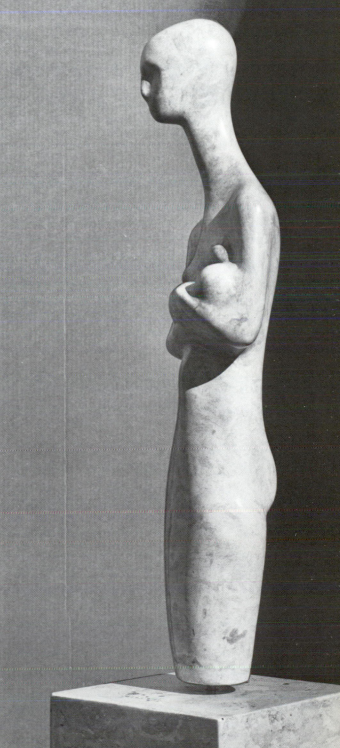

Jody, private collection.

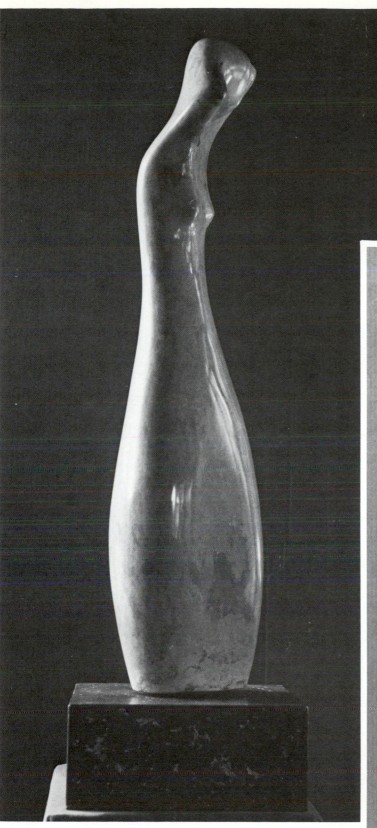

Mother and Child, private collection.

85

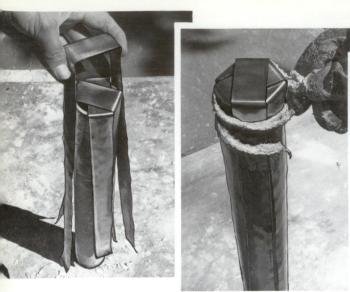

To make a large, free-to-turn design fill a galvanized steel pipe with a sand-cement mix to stiffen the pipe and prevent corrosion on the inside. Fit steel strips, preferably stainless, over the pipe as shown at left, above. Tie the strips with a loop of wire and wind fiber-cement around them. Then wind many turns of wire around and into the still fresh fiber-cement.

As soon as the cement sets firmly remove the pipe from the cylinder you made, oil lightly, and re-insert into the cylinder. Mount the pipe in a sturdy platform and build the sculpture on the cylinder. Build the base to receive the lower end of the pipe. See pages 52-53 for illustrations of how this design was completed.

After design is finished apply heavy grease to keep pipe free of corrosion.

Upper part of two-part base fits over pipe. Note four holes for bolting to lower part of base.

86

XIII. Miniature Designs

You can use the basic techniques described earlier to sculpt very small designs such as decorative pins, buttons, pendants, chess pieces, and fishing lures. In these you combine fiber-cement with small gauge wire to shape small forms upon which you carve details and then burnish or paint to finish. Some of these miniatures can be made without wires but the wire will protect against breakage and can provide loops for fastening to neck chains, cords or split rings.

The pendant shown on this page was made with copper wire bent to outline the form, packed with a mixture of bronze wool and white cement and then trimmed with rasps, files and a sharp knife. The bronze fibers reacted with the white cement to produce tiny blue lines and the copper wires, exposed by filing, revealed lines of copper luster.

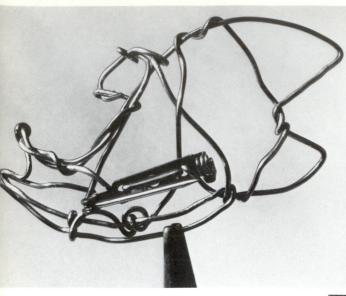

Run wire through the holes in a pin-back and bend to outline the design. Pack with fiber-cement, trim with tools and burnish or paint.

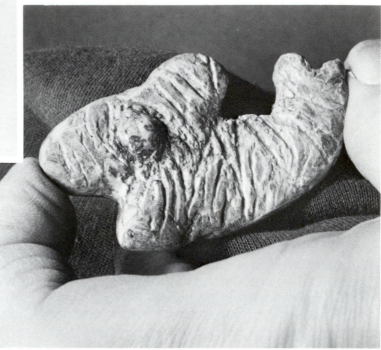

To make a decorative button let the wires encircle the holes in the button, pack with fiber-cement, trim and finish.

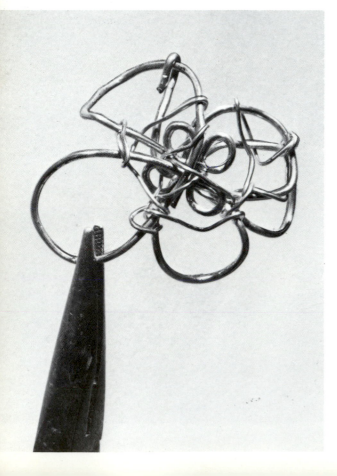

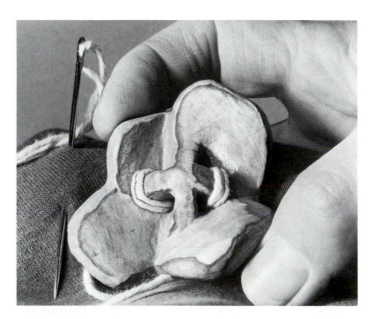

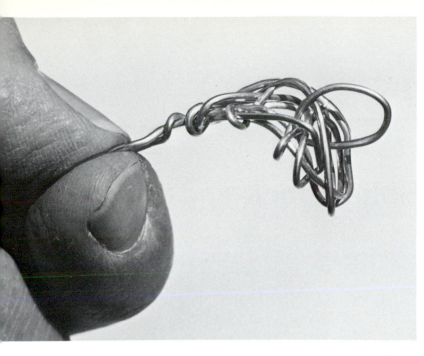

Shape wire for a fishing lure with a loop at one end for the split ring and hook and another loop at the other end for the leader. Pack with fiber-cement, trim with tools and color with acrylic paints.

To make a chess piece pack fiber-cement between four pieces of wood to make a small block. When set firmly clamp the block into a vise and cut with rasps and files. Burnish as it hardens.

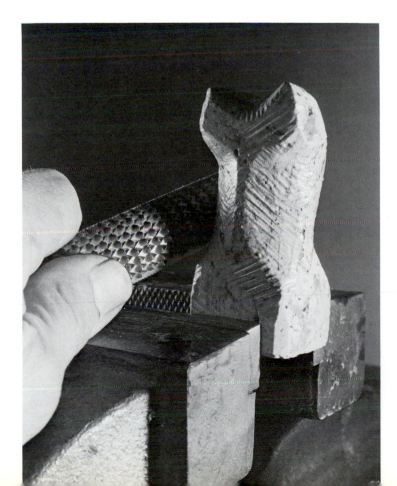

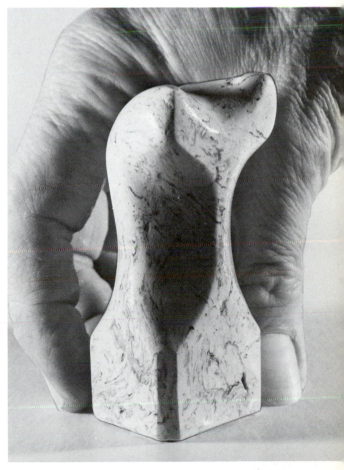

89

XIV. Carving the Solid Block

As you noticed in previous chapters the fiber-cement surface of any design can be cut and carved with knives and rasps. If you mix cement with water only — making what is known as *neat* cement — and let it set, you can carve it with the usual carving tools.

To shape the block use any container that can be easily removed such as a large milk carton, the adjustable mold described in the chapter on bases, or place four concrete blocks to enclose a rectangular space. For a larger block build a box shaped form with scrap lumber.

Mix the cement with as little water as possible to produce a thick, clay-like mass so stiff it stands up by itself. Since this mixture contains no sand or steel shrinkage cracks can be expected in the surface as it eventually dries. Reducing the water to a bare minimum will keep the shrinkage cracking to a minimum as well as give the hardened cement the maximum ultimate strength. See Chapter 5 to review the reasons for limiting the water. A mixture this stiff is difficult to stir and must be kneaded and squeezed through the fingers to distribute the scant water throughout the mass. Aggregate such as powdered marble can be included if desired but anything added should itself be soft enough to be cut by carving tools. Sand, for instance, will be avoided as it would destroy the cutting edge of steel tools. To obtain a grain quality in the finished design add a small amount of pigment after mixing but do not mix it in completely. After carving and finishing, the incompletely mixed pigment will appear as irregular, curved lines.

Since a mix this stiff is best made in small quantities it may require several mixes to fill your container or form. Drive each batch into place with a piece of lumber or other tamping tool to force out most of the small air pockets. Several of these air pockets will remain to appear in the surface after carving. They can be left as is or filled with cement paste.

As soon as the cement has set remove the container carefully to avoid breakage and test the hardness by cutting gently with a sharp tool. Soon after setting firmly it should still be soft enough to carve with a sharp knife or a wood chisel. Within a few more hours it will harden enough to require a chisel and hammer. The claw — a stone-carving chisel with a toothed edge — works well in roughing out the basic shape. Cement has a tendency to chip out larger pieces than you intend to remove so tap lightly with the hammer.

Plan a simple design limited to a few masses. This carved design has no steel reinforcement so avoid thin sections that could break off easily. Remove the large amounts of material while the cement is still fairly soft. Remove smaller amounts as the cement hardens and then carve the fine details as soon as it has hardened enough to support them. A sharp knife or wood chisel will cut many of the deeply indented details before the cement has fully hardened. Since the hammer and chisel frequently remove excessive amounts you may prefer to shape the contours and details with a rasp or coarse file. As in carving any stone riffler rasps work best in the concave areas and tight corners.

If too much is accidentally removed or if a corner breaks off it can be replaced with fresh material. See Chapter 4 to review repair techniques.

SAFETY NOTE: Always wear eye protection when carving with a chisel and hammer.

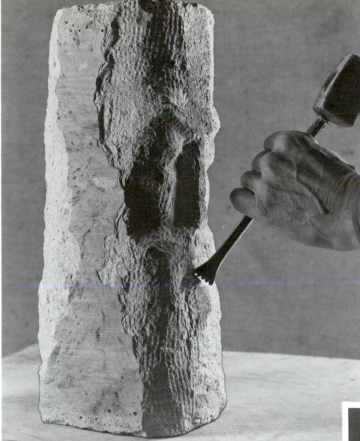

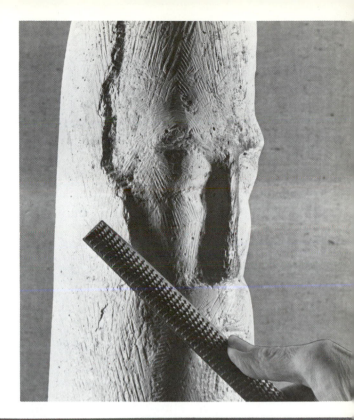

Swirling black lines in the surface due to black pigment mixed incompletely while preparing the block.

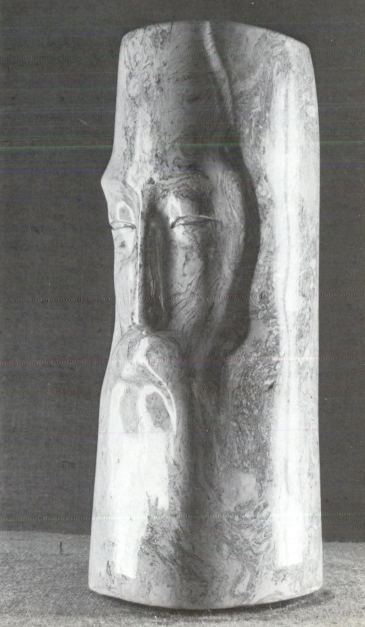

XV. The Sculptured Wall

An otherwise monotonous concrete block wall or a solid, poured concrete wall can be turned into an attractive mural with the application of cement mix. Any variety of designs are possible ranging from the very low relief to the high relief that casts deep shadows. First clean the wall thoroughly and remove all loose material. To assure good bond brush on a slurry made with acrylic latex and use latex in the cement mixture such as a solution of half latex and half water.

The design shown here was made by applying a thick mixture of sand-cement and then pushing a trowel through the mix before it had set so the wake of the trowel would make a series of curled and irregular forms. A strong vertical motif was used to offset the effect of the low ceiling and the straight lines were relieved with occasional curved motifs suggesting an organic growth.

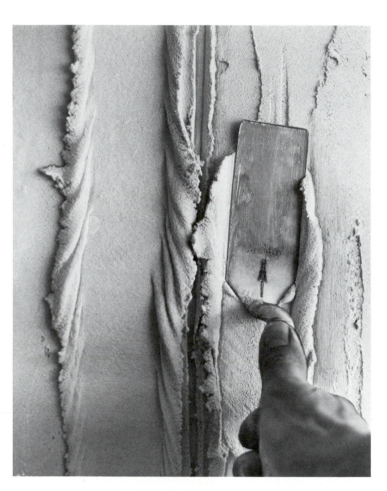

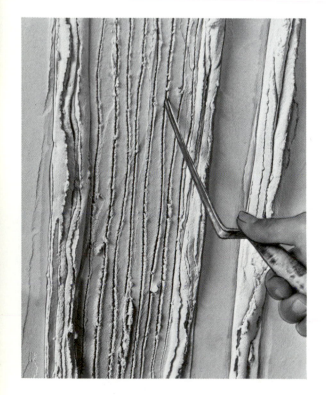

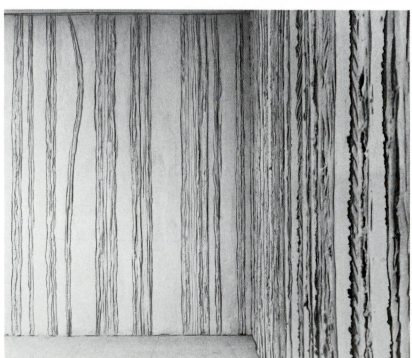

XVI. Casting the Portrait Bust

In making a portrait some may prefer modeling in clay and then casting the design in cement. This means making a plaster waste mold, packing the mold with cement mix, and then removing the mold. Moulding plaster is sold at lumber yards. A tincture of green soap, sold in drug stores, makes a good release agent.

To obtain a smooth and polished surface on the casting line the mold with fiber-cement. To eliminate shrinkage cracking, use acrylic latex polymer in this surface layer. Reinforce the casting with steel wires. If the bottom of the mold cavity is wide enough you can reach inside to place the steel and to cover it with an inch of sand-cement and still have a hollow casting. If you cannot reach inside you may have to pack it full of mix and make a solid casting without adequate reinforcement. In designing the clay portrait bust we can place abundant hair around the neck so the mold cavity will be wide enough for your hand to reach inside.

Larger designs, and especially those in which you cannot reach inside the mold to properly place the reinforcement, are best built by the direct methods described in previous chapters. Surface reinforcement, especially the many small gauge wires, can never be properly placed inside a mold. Even portraits can be made using direct methods that avoid the casting process.

Curing should begin while the casting is still in the mold. As soon as the cement has set turn the mold upside down and fill it with water. Then completely wet the outside of the plaster mold and keep it wet so the water can pass through the plaster to reach the outer surface of the casting. This method has water penetrating all sides of the casting to promote curing and hardening.

1. Push shims into clay to divide portrait into two parts, front and back.

As soon as the cement is hard enough, remove the mold by carefully chipping away small parts with a chisel. Remove the mold from the back of the head first so you do not injure the delicate facial features while chiseling away the plaster at the back of the head. When making the mold tint the first layer of plaster with a color. While chiseling away the mold the tinted layer warns that the chisel is closely approaching the delicate casting and gentle taps are recommended.

After removing the mold several small holes will appear in the surface. These can be filled with a polymer modified mix. After the fillings set and begin to harden the surface can be finished with tools and silicon carbide paper. After the cement has thoroughly dried a coating of methyl methacrylate can be applied and buffed. Carnauba wax can be added to enhance the gloss.

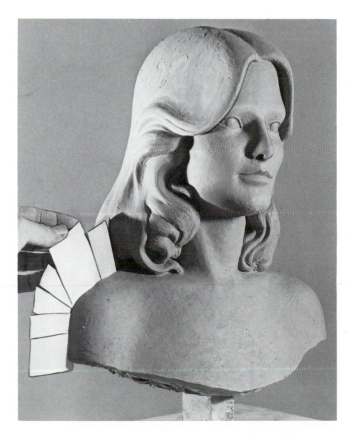

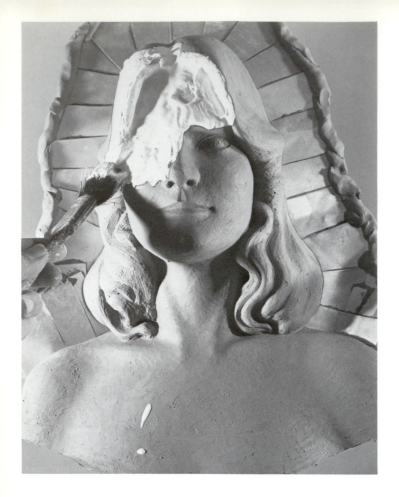

2. Mix plaster to a creamy consistency and squeeze out all lumps with your fingers. Add pigment to color the plaster and brush or throw this first coat on the clay. Continue adding coats of white plaster (without pigment) until the mold is one or two inches thick (3 to 4 centimeters). Add lengths of wood to final layer of plaster to reinforce the mold.

Note roll of clay fastened to shims to keep them in line.

3. To remove mold drive wedges gradually into shim line on all sides. Wash all clay from mold and apply tincture of green soap to inside of mold surface to facilitate later removal of mold from cement casting. If plaster does not absorb green soap let dry for day or two.

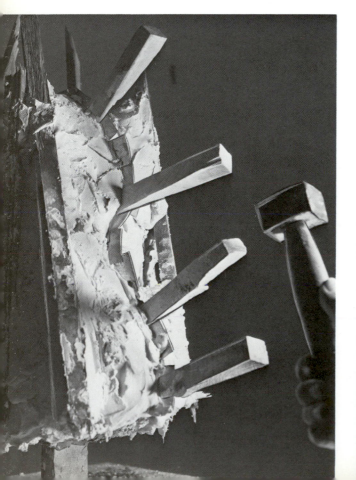

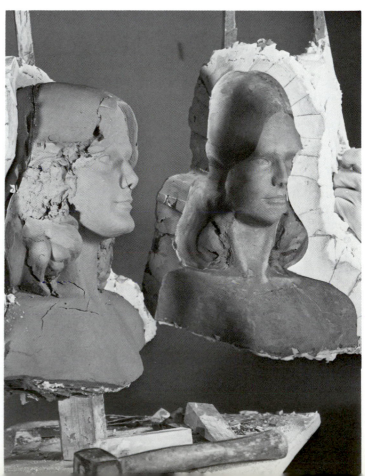

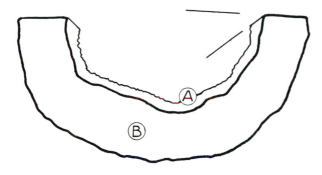

4. Pack thin layer of fiber-cement "A" against surface of mold "B." Bevel the fiber-cement along the edges where the mold sections will join. Place heavy wires in critical areas such as nose, brow, chin and protruding curls of hair over forehead and cover them with sand-cement.

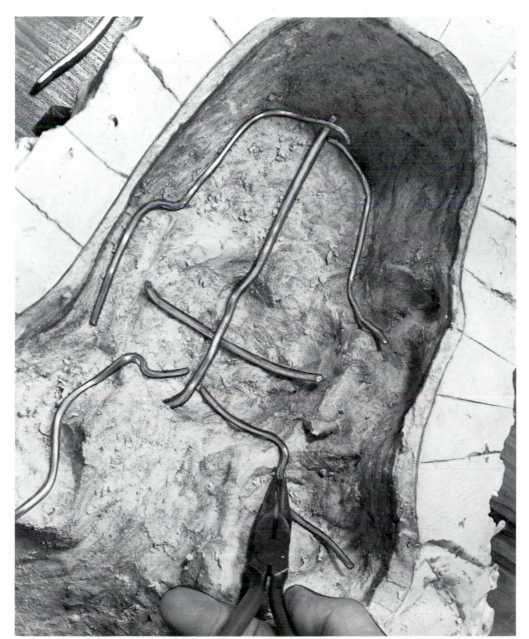

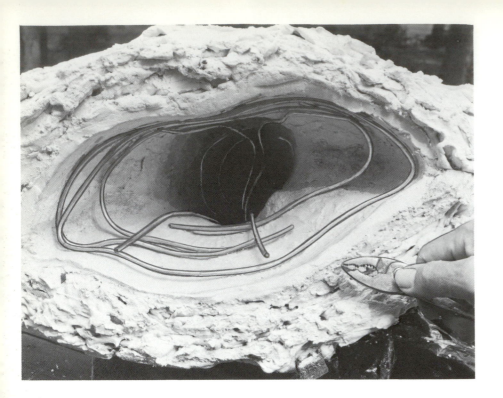

5. Assemble the mold and fasten along outside of joint with plaster ties made by mixing plaster with burlap or other fiber.

6. Brush slurry into the V-shaped gap along inside of joint and then fill this gap with fiber-cement "A". Fit heavy wire loops so they cross over the joint line. Brush slurry on all surfaces and cover with about an inch (2 or 3 centimeters) of sand-cement "B".

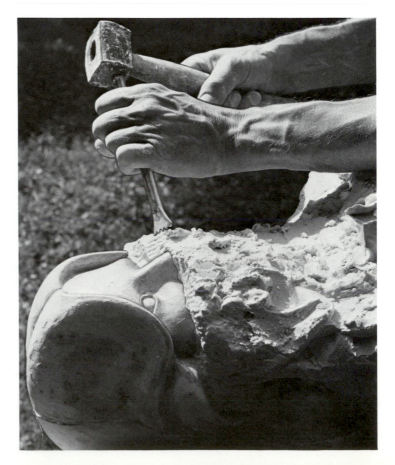

7. Colored plaster tells you when chisel is approaching casting and gentle taps are required. Plaster is removed from back of head first to avoid injury to facial details.

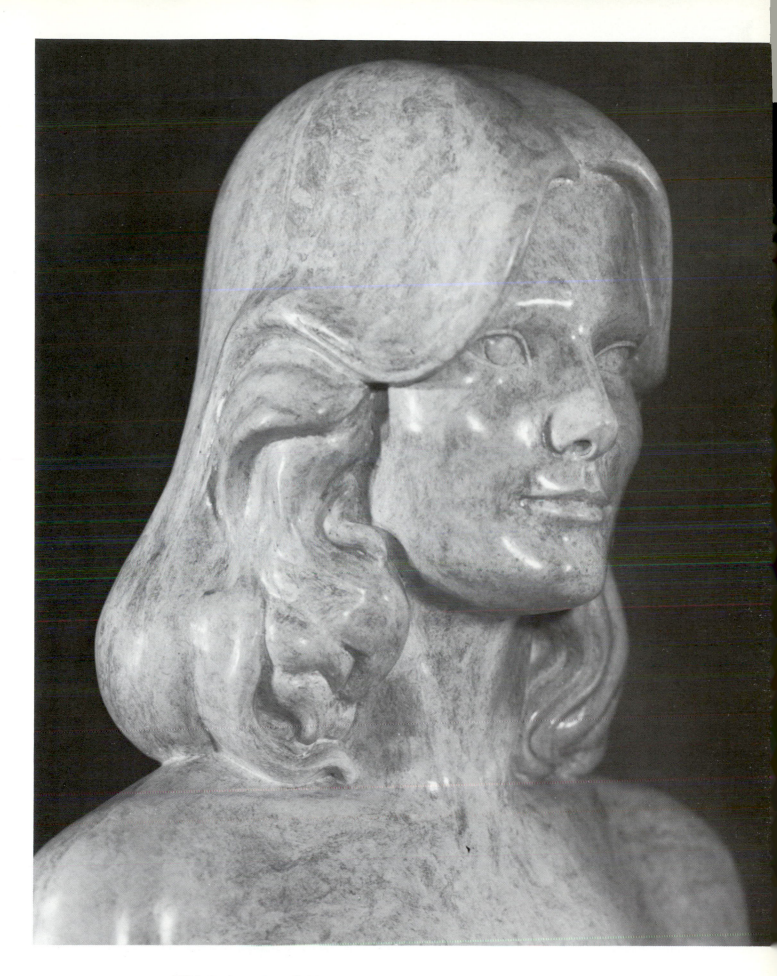

Fill holes in surface, finish with silicon carbide paper and, after cement is thoroughly dry, coat with methyl methacrylate.

Karen, life size.

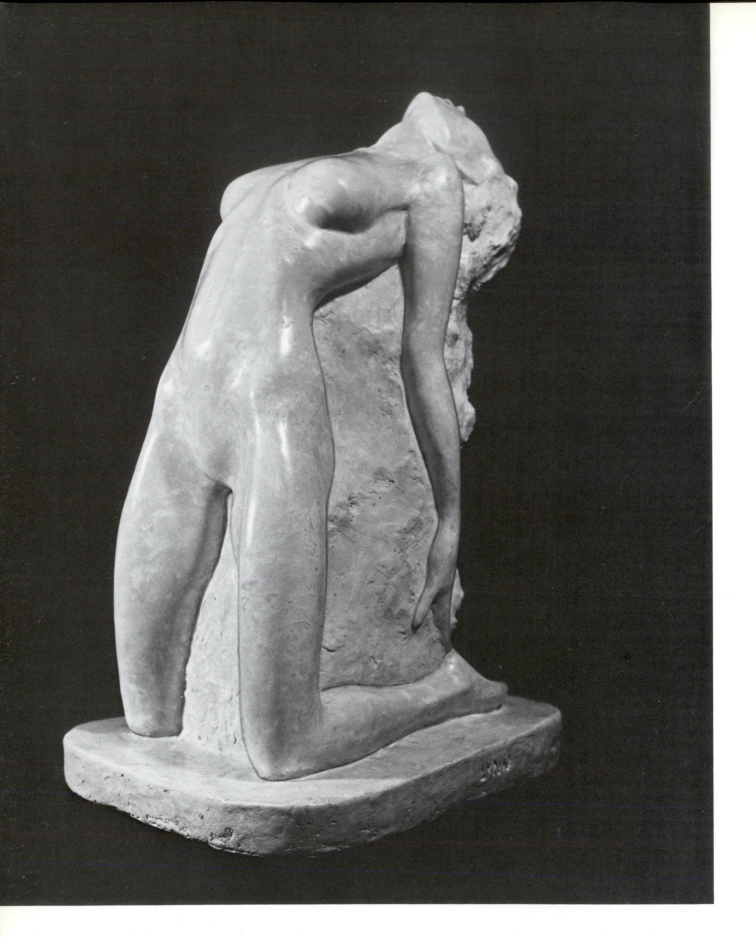

Figure modeled in clay and cast in glass fiber-cement from plaster mold made similar to procedure outlined for portrait bust. Note that this design is also wide enough at bottom so a hand can reach into the mold to arrange the necessary materials.

Dawn, 18 inches (46 centimeters).

XVII. Potentials of Direct Cement Sculpture

The flexibility of techniques and variety of applications means that direct cement sculpture offers many possibilities yet to develop. Large-scale sculpture in particular benefits from a direct approach not encumbered by awkward molds. An outstanding example of what direct techniques can accomplish are the Watts Towers built by Simon Rodia in Watts, California between 1921 and 1954. Rodia was an Italian immigrant with no art training and was a tile setter by trade. Working single-handed in his spare time, using only cement, sand, steel rods, angles, tees, poultry netting, hardware cloth and wires–with no welding, no rivets and no bolts–Rodia built seven open web towers, one of them 100 feet tall (30.5 meters.) His towers are now internationally acclaimed esthetic achievements. With no training in engineering, he intuitively constructed strong and durable designs that survived the 1932 earthquakes and that reveal the essential connection between structural efficiency and esthetic beauty.

Between 1879 and 1912 the postman, Ferdinand Cheval, built his Palais Idéal in Hauterives, France. These architectural sculptures are among the earliest attempts to sculpt directly in cement, stone and wire and are now internationally recognized. Another early example of direct sculpture with cement, sand and steel is the Garden of Eden with about 150 figures and thirty trees, built in the 1910s–20s in Lucas, Kansas by Samuel Dinsmoor.

Compare this direct technique with a casting method. The Black Hawk monument that stands above the Rock River near Oregon, Illinois was built of portland cement, sand, granite chips and other aggregate and was cast in plaster molds. Reinforced with steel, the sculpture stands 43 feet, four inches (13.2 meters) above the base and was erected in the fall and early winter of 1910. Based upon a six-foot (2 meters) clay figure modeled by Lorado Taft, the final sculpture was built by a crew under the supervision of John G. Prasuhn, a sculptor experienced in concrete construction. Concrete mixers, cranes, and other heavy equipment were necessary for the construction. By contrast, the Watts Towers, over twice as tall, were built by one man, working alone, with only a few simple hand tools, a bucket and a window washer's belt to support him high up on the towers.

Professional engineers were consulted for advice on the construction and reinforcement of the Black Hawk sculpture. Simon Rodia followed only his own intuition when reinforcing and constructing his towers. The years have proved the validity of the engineering of the Black Hawk monument. While the years have also proved the validity of Rodia's engineering intuition, the towers were actually condemned to demolition in 1959 when city authorities declared them a hazard to the safety of nearby buildings. Concerned persons acted to save the towers and a test was devised in which a 10,000 pound (44,480 N) horizontal force, more than the maximum possible wind load, was applied to the tallest tower. The tower survived the test with no damage, all the towers were then declared safe, and these esthetic monuments were saved.

Most of us have developed, as had Simon Rodia, an intuitive understanding of how materials behave as we use them, break them, and discover ways to use them without breaking. But often this intuitive understanding is not enough to build what we want the way we want it. Unlike Rodia, most of us would hesitate to build a 100 foot tower on intuition alone. To prevent structural failure, we often make our designs thicker and heavier than necessary, and thus lose the balanced proportions we would prefer. Fortunately, we can improve our intuitive sense of structure by considering how materials behave as they react to forces and this can help us design in the dimensions and proportions we want. Understanding concepts about structure can improve our capacity for esthetic design.

STRESS AND STRAIN

Stress and strain are what happen inside a material when a force is applied on the outside. The forces inside are called *stress* and are measured in pounds per square inch or kilopascals. The material absorbs stress by changing shape, what is called *strain* and is measured in inches or millimeters. For example, in steel a tensile stress of 30,000 pounds per square inch will stretch the steel through a strain of 0.001 inch per inch.

Stress can take on three different states and each has a corresponding strain. *Tensile* stress tries to pull the material apart and so tensile strain is a stretching of the material. *Compressive* stress tries to push the material together and therefore compressive strain is a shortening of the material. Both tensile and compressive stresses operate perpendicular to the section upon which they act. *Shearing* stress operates parallel to the section upon which it acts and tries to slice or twist the material. Shearing strain is a sliding of one section over another, or a tendency of the material to slice apart.

Tensile or compressive stresses are accompanied by shearing stresses. Since most materials are weakest in their ability to resist shear rupture is usually due to shear and the slicing is at an angle of 45° to the tensile or compressive stresses.

Since rupture is by shear any structural member should be reinforced to resist shear. In a linear member such as an arm or a leg the longitudinal rods resist tensile and compressive stresses. Helical or spiral windings of wire are placed over the longitudinal rods at about 45° to resist shearing stresses that tend to push the rods apart.

Stress and strain are generally proportional. The more stress, the more strain. You can estimate the stress in any member by observing the strain. If you notice that some member bends excessively you can assume it is over-stressed and needs to be stiffened.

Stresses are not always uniformly distributed. They tend to concentrate at any discontinuity such as the edges of cracks or sharp corners or where the density of a material radically changes. These stress concentrations are several times the average stress and can cause small micro-cracks to widen and lengthen into larger cracks and fractures. Stress concentrations are often used to facilitate cutting. When glass is scored with a glass cutter and then bent the bending stresses concentrate along the scratch and produce a straight cut.

THERMAL STRESSES

Temperature changes can produce extremely high stresses. As temperature rises any material expands and as temperature drops the same material contracts. Sunshine heats the outside of a sculpture, makes the outer surface expand while the inner material remains cool and does not expand. The expanding surface tries to pull away from the inner material and severe stresses can develop between the inner and outer parts. Later, as the heat penetrates, the inner material also expands and the stresses may be relieved. Still later, rain falls to suddenly cool the outer surface which then contracts. The inner material, still warm, does not contract so again severe stresses develop between the inner and the outer parts. The shrinking outside can crack to relieve the tensile stresses.

Consider the effect of alternating sunshine and rain on a flat panel design or bas-relief mounted on a wall. As the hot sunlight raises the temperature of the outer surface it expands while the cooler inner surface does not. Expansion of the outer surface makes the panel bend outward. As the inner surface slowly absorbs heat it too expands and the panel straightens. Then it rains and the outer surface cools quicker than the inner surface. Now the contraction of the outer surface bends the panel in the opposite direction. With every change from hot sun to cold rain the panel bends back and forth. Cracks can appear to relieve the alternating stresses and water can freeze in the cracks to further the damage.

Large panels bend more and suffer more stress than small panels. A large design can be divided into many small panels to reduce thermal stresses.

Reinforcement for thermal stress means abundant small gauge wire close to the surface and covered with only enough cement to prevent corrosion. Using stainless steel wires in the surface is advisable. Whenever possible build the design as a hollow shell. The less material inside the less stress between the inside and the outside.

ELASTICITY

When stress is removed strain may disappear and the material may return to its original shape. This ability to return to its original shape is called *elasticity* and is measured in stress units. The more stress a material can absorb and still return to its original shape the higher its elasticity.

Because of its high elasticity, steel stretches very little when stressed so when used as reinforcement it

can absorb the stresses that would otherwise overstrain the cement matrix. When steel is well distributed throughout the cement matrix, as in ferro-cement, the entire structure takes on much of the elasticity of the steel. The finer the wires and the more uniformly distributed the more elasticity the ferro-cement will have. The spiral windings of wire applied to absorb shearing stresses also contribute to the elasticity of the design.

DUCTILITY

When a material is stretched or bent so much it can no longer return to its original shape, it has been stressed beyond its *elastic limit*. Beyond the elastic limit a *brittle* material will break while a *ductile* material will continue to change shape without breaking but will never return to its original form. For example, if you bend a sheet of brittle glass beyond its elastic limit it breaks. When you bend a sheet of ductile steel beyond its elastic limit it remains bent but it does not break. Instead of breaking the steel absorbed the stresses by yielding to assume a permanent deformation and so retained its usefulness. The magnitude of stress at which steel begins to yield is called its *yield point* and the ductility associated with yielding is particularly important to the usefulness of any material. Stresses tend to concentrate at any irregularity such as a sharp corner or cut. A ductile material can yield to these stress concentrations by taking on small changes in shape and continue to serve its purpose. Since it cannot yield to stress concentrations a brittle material breaks.

This contrasting behavior of brittle and ductile materials helps explain why so many bronze sculptures of antiquity have survived intact while most of the marble sculptures have broken. The ductile bronze could absorb stress concentrations by yielding while the brittle marble could not.

Cement is brittle; steel is ductile. The more the steel is closely spaced and evenly distributed throughout the cement matrix the more ductility will develop in the total structure. The cement provides lateral support to the steel wires so they can develop their qualities of strength, elasticity and ductility. This gives us a composite material that can be shaped into any complexity of form and to any size.

VIBRATION AND FATIGUE

In a strong wind you may have seen a traffic sign rapidly twisting from side to side on its slender steel post. The elasticity of the steel post allows it to rapidly absorb and release stresses resulting from the wind pressure and a *vibration*, a rapid reversing movement, develops. As the wind continues the accumulating stress can cause rupture. Vibrations from the wind have actually destroyed a modern steel suspension bridge.

Any large sculpture installed outside can develop destructive vibrations in a strong wind and designing for such stresses is extremely difficult as height, weight, configuration and number of supports all affect its susceptibility. For example, a tall thin design mounted on a single stem, similar to the traffic sign mentioned above, is subject to vibrations in both the horizontal and vertical planes. Vibrations in the horizontal plane can be eliminated by building the stem so the design is free to rotate but vibrations in the vertical plane can only be controlled by making the stem thicker or adding more stems either of which can affect the design.

Vibrations not severe enough to cause rupture can produce continuous stress reversals in several parts of the design. If stress reversals continue long enough *fatigue* weakens the ability of the material to absorb stress and this can lead to failure.

FORCES AND REACTIONS

Forces that can act upon a sculpture include its own weight, impacts, temperature changes, wind pressure and vibrations. The exact magnitude of these forces is difficult to predict and no force acts alone. Each force creates a reaction that is equal in magnitude and opposite in direction. The weight of a sculpture pushes down and a reaction pushes up to counteract the weight. The wind pushes from one direction while a reaction pushes at the base to oppose it. Reactions seldom develop along the same axis as the force that causes them so the two opposing forces produce a *couple* that would rotate the sculpture. If the sculpture is not to rotate, this couple must be counteracted by another couple trying to rotate in the opposite direction. Since each couple consists of two forces we now have four forces resulting from that one original force. See the drawing that illustrates three reactions "R" produced by one wind force "F." In deciding how slender and how tall we can design any large sculpture and in deciding how to reinforce it we need to carefully evaluate all forces and reactions that may act upon it.

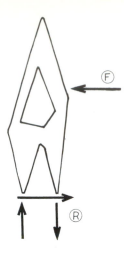

Note that a standing sculpture would have more than the two legs shown in this drawing. Each leg would have its own reaction force and the magnitude of each reaction would depend upon the number of legs and the distance between them.

MOMENTS

Wind pressure varies with location. The design wind pressure (force per unit area) may be selected by the engineer or prescribed by the building code and is expressed as pounds per square foot or pascals. The area that the design presents to the wind (the effective projected area) is multiplied by the pressure per unit area to obtain the total wind force. Then the centroid of the effective projected area is determined and the distance of this centroid above the base is estimated. The total wind force is multiplied by the distance of the centroid above the base and this product is the moment at the base. Moments, like couples, tend to bend, rotate or overturn. The overturning moment produced by the wind must be resisted by the sculpture and its connections to the base.

Earthquakes create seismic forces that are impossible to predict. The moments and vibrations they produce require special consideration.

PROFESSIONAL CONSULTATION

The above examples suggest that it is one problem to make a small model for a large sculpture but an entirely different problem to design and build the larger sculpture. Larger designs are heavier, block more wind, absorb more heat, create larger reactions, larger vibrations and larger stresses. To design on a large scale, and to use material most efficiently so the shape and form have the best esthetic proportions, the services of a professional structural engineer are advisable.

The Black Hawk monument was constructed after engineers analyzed the structural requirements. Paul Landowsky designed the model for the Christ sculpture (1931) that stands upon Mt. Corcovado, overlooking Rio de Janeiro. Engineers analyzed the structural problems for this 30 meter (98½ feet)

sculpture and supervised its construction.

An example of cooperation between the engineer and volunteer workers was in the construction of the Sperm Whale at the Children's Museum in West Hartford, Connecticut. Built of ferro-cement, a combination of wire mesh and sand-cement such as discussed earlier in the chapter on shell design, the Sperm Whale is 60 feet long (18 meters) and 20 feet tall (6 meters). A hollow shell design, the inside of the Sperm Whale accommodates 29 people. Designed and supervised by an engineer, the construction required 5000 hours of volunteer labor.

PRESTRESS DESIGN

An example of consultation between designers, engineers, precasting plants and erectors is the De Gaulle Memorial in Colombey-Les-Deux-Eglises, France. In the form of the Cross of Lorraine, this prestressed concrete structure stands 44 meters (144 feet) above the base, and its longest horizontal arm reaches out 7.56 meters (24.8 feet). The width of the vertical stem is only about two meters (6.7 feet) and most of this is hollow space with only 25 centimeters (10 inches) for the thickness of the shell. In addition to supporting the entire weight, this ten inch shell can counteract stresses developed by a wind force of 100 tons (90,700 kilograms). This prestressed concrete design was cast in 45 separate sections and steam cured. The sections were assembled with cables running through them. The cables were tightened to prestress the concrete. Similar horizontal cables prestress the arms.

The extreme slenderness of this hollow shell design suggests the possibilities that prestress techniques have for sculpture. In prestress design permanent compressive stresses are forced upon the cement matrix usually by tightening cables that run through it. Forces, such as wind pressure, that would cause tensile stresses in ordinary designs, serve instead to relieve some of the compressive stresses in prestressed designs and therefore no tensile stresses develop. Since cement mixtures are weakest in tension, prestress design overcomes this weakness by eliminating tensile stresses and makes larger, more slender designs possible.

Prestress design can be pre-tensioned or post-tensioned. In the former the steel wires or cables are tightened before the cement mix is placed. In the latter the steel is tightened after the cement has hardened.

The prestress steel can only be tightened when straight or slightly curved so prestress designs are usually simple forms with straight sides. The prestressed concrete sculpture *Adventure in Concrete*, designed by Hal Buckner and installed at the Concrete Technology Corporation offices in Tacoma, Washington is an excellent example of how almost straight sides subtly tapering from bottom to top align with the prestressing cables inside. This sculpture is also an example of cooperation between the sculptor and consulting engineers.

EXPANDING CEMENTS

Cements that expand as they set can prestress themselves and control shrinkage cracking. If this expansion is restrained by the reinforcing steel compressive stresses will develop in the cement. Later, as the cement dries and shrinks some or all of the compressive stresses are relieved. But the shrinkage is not enough to develop tensile stresses and shrinkage cracks.

The steel must be arranged so it will effectively restrain the expansion of the cement. Expansion is in all directions and the ferro-cement techniques using multiple layers of wire mesh tied to each other may provide the best restraint in all directions. Abundant helical windings of steel wire near the surface of a linear member (as described in previous chapters) provides good restraint. Stainless steel or brass wires in the surface will restrain surface expansion without corrosion.

Expansive cements, also known as shrinkage-compensating cements, depend upon the formation of ettringite as the expansive component. Expansion at the optimum time is essential so proper mixing and curing is required. Refer to the technical literature for procedures.

An expansive cement can be made by combining 75% portland with 20% calcium aluminate and 5% gypsum. An expansive component is available for adding to ordinary portland.

CREEP

Over an extended time any material under stress takes on a slight but permanent change in shape that relieves some of the stress. This shape change is know as *plastic deformation* or *creep*. In prestress design creep can gradually relieve enough compressive stresses in the cement matrix to destroy the prestress advantage. Prestress engineers employ

techniques to minimize the effect of creep.

Creep is also a problem in ordinary design. Consider a long horizontal member fastened at one end such as an arm of the Christ sculpture overlooking Rio de Janeiro. One arm weighs 80 tons (72,560 kilograms) and the bending moment this weight creates at the shoulder produces compressive stresses on the bottom side and tensile stresses along the top. Unless the bottom of the arm were as carefully reinforced as the top, creep would eventually allow the arm to deflect downward.

MOVING STRESSES

Moving a large sculpture from the studio to the installation site can develop stresses much greater than those that occur after installation. Unless the sculpture is carefully designed and reinforced to resist these moving stresses it can arrive at the site seriously damaged. The moving damage can be hidden—such as cracks concealed beneath the surface. The hidden cracks concentrate stresses and can enlarge later into visible fractures with no apparent explanation. The steel reinforcement should be planned to absorb stresses due to moving and installation as well as those described above.

Extreme moving stresses can be eliminated by building a large design in small sections and then assembling the sections on the site (see pages 74-75). Each section can be reinforced to absorb moving stresses. The primary reinforcement or prestressing is then built in at the site as the sections are assembled. Polymer modified cement can fill and seal the joints. Special epoxies and silicones are also available for bonding the sections.

Sections can be bolted together if matched openings are left for inserting the bolts. Threaded rods (preferably stainless) can be built into the sections so as to enter an adjacent section and then tightened with nuts. It may be desired to obtain a close fit between the sections (see page 70.) One section can be built against the other with a thin film of plastic between them. The plastic is removed before the sections are assembled.

GEOPOLYMERIC CEMENTS

Recently developed geopolymeric cements are based on natural minerals and form a zeolitic binder. They are heat stable and have low volume change—which means very little shrinkage cracking. They have high early strength and very high resistance to freeze-thaw damage. Their setting

rate can be controlled. Not widely available they may become more so in the future. See the book: Davidovits, J. and Morris, M. *The Pyramids, An Enigma Solved*, Hippocrene Books.

SLAG CEMENT

Iron blast furnace slag, when quenched with water, is ground into a slag cement. Like portland it forms calcium silicate hydrates but it does not produce calcium hydroxide. It is stable at high temperatures. Fibers and polymers can be used with it. Off-white in color, it can be pigmented and polished with silicon carbide papers. The blue color that appears after setting is not permanent.

With water alone it does not set. An alkali in water such as sodium silicate or sodium hydroxide (household lye) activates setting. Strong alkalies attack zinc so galvanized reinforcement may not be compatible. Stainless or bare steel may be advised. Excessive alkalies can reduce strength so only the amount required to activate should be used. Hydrated lime can retard its setting rate for a longer working time. It may have more drying shrinkage and may suffer more carbonation (attack of CO_2 on alkalies) than portland. A low water-cement ratio and proper curing can limit these effects.

The alkalies in portland activate slag cement. A blend of 10% portland and 90% slag sets slowly and allows more handling time than portland. Setting rate increases with more portland and a blend of 50/50 is common. When mixed with portland the slag cement modifies the pore size distribution toward smaller pores and also reduces the total pore volume. The finer the slag is ground the more pronounced the effect which also increases with time. Silica fume or other pozzolans with a superplasticizer further reduce porosity. This reduction in porosity reduces water penetration with a decrease in water-borne deleterious agents and an improved durability. As in all mixtures a low water-cement ratio improves durability.

LIGHTWEIGHTS

Lightweight aggregate (page 25) can reduce the weight of a design. Aluminum powder in wet portland cement generates hydrogen gas. The bubbles double the volume to make a lightweight material that can be readily cut and shaped.

SHOTCRETE

A cement mix under pressure can be propelled from a nozzle to adhere to a surface and the reinforcement in front of it. Sculptures have been built with this method. For reliable results a specially trained shotcrete crew is required.

REFRACTORY CEMENT

Calcium aluminate cement sets slower but hardens much more rapidly than portland. It has been used for structures and for sculpture. But its initial hydrate is not stable and in time converts to a stable form with shrinkage and loss of strength. Buildings made with it have collapsed and it is banned for structures in most countries. It is still being offered for sculpture under misleading trade names and with no mention of its instability.

Mixed with a refractory aggregate such as sintered alumina and fired at 1500°F (815°C) it forms a stable ceramic bond so its main use is as a refractory cement. This suggests it could be used for ceramic sculpture fired in a kiln.

SULFUR CEMENT

A modified sulfur cement is 95% sulfur with 5% modifier added to improve durability. It resists acids and salts and is impervious to water. It melts at 246°F (119°C) and is applied at 270°F to 280°F (132°C to 141°C). Above 300°F (149°C) it becomes unworkable.

Fibers of steel, glass and carbon can be mixed with the melted sulfur. Powders can be added as fillers. The cooled sulfur fiber-cement can be tool worked and polished with silicon carbide papers to develop an attractive range of soft grays with an intriguing gloss. A veneer of sulfur fiber-cement can be applied to a portland cement design. Shrinkage cracks can be widened with a knife and filled with melted sulfur.

Aggregate can be heated with the sulfur or before adding to the sulfur. Heated aggregate can melt the sulfur. Slag, expanded clay-shale-slate or ceramic spheres are suggested as these can be tool worked.

Heating sulfur safely requires careful planning. A heating device that controls the temperature is essential. Overheating can set the sulfur on fire and release toxic sulfur dioxide gas. Overheating can also destroy the modifying agent and leave the sulfur brittle. Heat sulfur only with adequate ventilation and preferably outside. Follow the recommendations of the National Safety Council for handling sulfur. Use eye protection, gloves and protective clothing.

POLYMER IMPREGNATION

Pores in the cement can be filled with a monomer such as methyl methacrylate. The monomer can be polymerized by heat to improve strength, elasticity, durability, impermeability and resistance to freeze damage. The process requires trained technicians.

FIBER PROPERTIES

Fibers with high strength and high elasticity in high fiber-to-cement ratios, with latex polymers and silica fume, or high reactivity metakaolin make an excellent fiber-cement composite. The concrete industry uses the term, "steel fibers" to mean short lengths of small gauge steel wires. Here "steel fibers" means steel wool of various diameters. This steel wool can be ordinary steel or stainless. The ordinary steel wool can create attractive rust-reds in the surface but does not usually rust below the surface of cement made with a low water-cement ratio. Stainless steel wool can create specks of metallic luster in the surface when finished with the finer grades of silicon carbide paper.

In selecting a fiber review the manufacturer's literature for durability in the alkaline cement, bond to the cement, tensile strength and elasticity ("modulus" is their term for elasticity). An important function of the fiber is to bridge over the microcracks to prevent their widening into large cracks. For this the fiber needs good bond to the cement so it will not slip. The fiber also needs tensile strength and elasticity (modulus) higher than that of the cement so it will not stretch more than the cement matrix if it is to provide reinforcement and microcrack control.

Bond involves *aspect ratio,* the ratio of length to diameter. *Critical length* is the minimum length that will develop enough bond to prevent pull out. Long, thin fibers develop the best bond and bridge over the most microcracks. Silica fume aids in the dispersion of fibers while mixing and also improves the quality of the transition zone along the fibers (see page 23) to improve bond. Latex polymers, especially at the higher latex-cement ratios over 15%, improve the bond and increase the tensile strength and impact resistance of the fiber-cement composite.

Carbon fibers are durable in cement. Both their tensile strength and elasticity (modulus) are usually higher than that of steel. In cement sculpture the PAN based fibers (from polyacrylonitrile) are usually preferred over the pitch based. The longer fibers in continuous strands develop the best anchorage for effective reinforcement.

Steel fibers are ductile (see page 101) while carbon fibers are brittle. A ductile steel fiber can yield (take on a permanent stretch) when stressed to its yield point. The brittle carbon fiber cannot yield but must break when stressed to its tensile limit. By using all fibers in large percentages so they are not stressed to their tensile limit their breaking or yielding is avoided.

Rotary mechanical mixers allow only small amounts of short fibers to be mixed with cement. Hand mixing allows larger quantities of long fibers that curve in many directions for maximum anchorage and reinforcement and for optimum esthetic patterns in the finished surface (see sculpture on front cover).

Some types of carbon fibers break up during mixing so use only those that retain their length in mixing. Request manufacturer's advice and obtain samples to test. They are available in short lengths and as continuous strand on spools and with or without coatings. The long fibers can be cut into desired lengths after wetting with slurry.

Because of their fine diameters carbon fibers easily become airborne. Avoid breathing of their particles and avoid skin contact.

Carbon nanotubes are hollow carbon fibers with diameters approximating one to 15 nanometers (one to 15 billionths of a meter)–much finer than other fibers. When they become available at a low cost their properties should be of value in cement.

Aramid fibers are stable in cement and are available as continuous strand, as staple and as pulp. The pulp fibers are very short and are fibrillated (branched) for better anchorage. Their tensile strength and elasticity are not as high as those of steel and high modulus carbon fibers but are high enough for good reinforcement of the cement matrix. Refer to the manufacturer's specifications.

Very fine polyvinyl alcohol (PVA) fibers have relatively high elasticity and tensile strength, bond well to cement and are durable in cement.

A fine diameter processed cellulose fiber is durable in cement, has relatively high elasticity and has been tested to perform well in controlling microcracks.

A fine diameter polyethylene fiber has relatively high tensile strength and elasticity. It is durable in cement and bonds well.

Other fibers, such as polypropylene, nylon and polyolefin are generally durable in cement. But they do not bond well so they slip and fail to prevent microcracks from widening. With their low elasticity they stretch excessively. This slipping and stretching can prevent the cracked matrix from separating into pieces. Glass fibers deteriorate in the alkaline cement and even the alkaline resistant fibers eventually deteriorate. With low elasticity they stretch excessively.

Very thin fibers require excess water to wet their surfaces so a superplasticizer becomes necessary to keep the water-cement ratio low.

APPENDIX — SOURCES OF MATERIALS AND INFORMATION

LIBRARIES

To determine what books are available on cement technology consult *Books in Print* in the reference department. Books and magazine articles not in the local library can often be obtained through the inter-library loan service. The *Thomas Register* provides names of companies for almost every product and material.

PROFESSIONAL ORGANIZATIONS

These organizations publish books or periodicals about cement technology. From these the sculptor can obtain information to adapt to sculptural purposes and to keep abreast of current research.

American Concrete Institute
38800 Country Club Drive
P.O. Box 9094
Farmington Hills, MI 48333
(248) 848-3800

Portland Cement Association
5420 Old Orchard Road
P.O. Box 726
Skokie, IL 60076
(800) 868-6733

Materials Research Society
506 Keystone Drive
Warrendale, PA 15086-7573
(724) 779-3003

American Society for Testing and
Materials (ASTM)
100 Barr Harbor Drive
West Conshohocken, PA 19428
(610) 832-9693

Advanced Cement Based Materials
Elsevier Science, Inc.
655 Avenue of the Americas
New York, NY 10010-5107
(212) 633-3747

Aggregate associations that provide technical information and the names of local dealers

National Slag Association
110 W. Lancaster Ave., Suite #2
Wayne, PA 19087-4043
(610) 971-4840

Expanded Shale, Clay & Slate Institute
2225 E. Murray Holladay Road, Ste 102
Salt Lake City, UT 84117
(801) 272-7070

Many companies offer materials for use with cement and concrete. Some offer a wide range of products such as superplastizers, polymers, retarders, pozzolans, fibers, corrosion inhibitors, sealers, coatings, and shrinkage reducers. Others specialize in a few products. They provide data sheets and catalogs that give detailed information about each product. The sculptor can study these for guidance and can telephone their technical representative for answers to specific questions and to request samples for testing

Companies with a large range of products for cement and concrete:

Master Builders, Inc.
23700 Chagrin Boulevard
Cleveland, OH 44122-5554
(800) MBT-9990

W.R. Grace & Co.
62 Whittemore Avenue
Cambridge, MA 02140
(617) 876-1400

Euclid Chemical Company
19218 Redwood Road
Cleveland, OH 44110-2799
(800) 321-7628

Boral Material Technologies, Inc.
45 N.E. Loop 410, Suite 700
San Antonio, TX 78216
(210) 349-4069

Fritz-Pak Corporation
P.O. Box 820636
Dallas, TX 75382
(888) 746-4116

Pigments (dry)

Daniel Smith
4150 First Avenue South
Seattle, WA 98124
(800) 426-7923

Bayer Corporation
100 Bayer Road
Pittsburgh, PA 15205-9741
(800) 662-2927

Retarder

Addiment Incorporated
P.O. Box 47520
Atlanta, GA 30362
(770) 446-6250

Epoxy admixtures

Miller-Stephenson Chemical Co., Inc.
George Washington Highway
Danbury, CT 06810
(800) 992-2424

Superplasticizers

Boremco Specialty Chemicals
106 Ferry St., P.O. Box 2573
Fall River, MA 02722
(800) 543-5393

Mold release agents

Cresset Chemical Co., Inc.
One Cresset Center
Weston, OH 43569
(800) 367-2020

Migrating corrosion inhibitor

Cortec Corporation
4119 White Bear Parkway
St. Paul, MN 55110
(800) 4-CORTEC

Ceramic spheres

Kinetico Incorporated
10845 Kinsman Road
P.O. Box 193
Newbury, OH 44065
(800) 432-1166

Elemental silicon

Elkem Materials, Inc.
Airport Office Park
P.O. Box 266
Pittsburgh, PA 15230
(800) 433-0535

Stained slab glass, sheet glass

Blenko Glass Company, Inc.
P.O. Box 67
Milton, WV 25541
(304) 743-9081

Silicone glass sealant (for isolating glass from cement)

GE Silicones
General Electric Company
Waterford, NY 12188
(800) 255-8886

Dow Corning Corporation
Midland, MI 48686-0994
(517) 496-6000

Fly Ash

Boral Material Technologies, Inc.
45 N.E. Loop 410, Suite 700
San Antonio, TX 78216
(210) 349-4069

Silica fume and elemental silicon
Elkem Materials, Inc.
Airport Office Park
P.O. Box 266
Pittsburgh, PA 15230
(800) 433-0535

Silica fume
Norcem Concrete Products, Inc.
P.O. Box 5537
Hauppauge, NY 11788
(516) 724-8639

White high reactivity metakaolin
Engelhard Corporation
Pigments & Additives Group
101 Wood Avenue
Iselin, NJ 08830-0770
(732) 205-7018

White pore reducing admixture
IPA Systems Incorporated
2745 North Amber Street
Philadelphia, PA 19134
(800) 523-3834

Blast furnace slag cement
Holnam, Inc.
6211 Ann Arbor Road
Dundee, MI 48131-0122
(734) 529-2411
(800) 831-9507

Cresset Chemical Co., Inc.
(Crete-Trete 930)
One Cresset Center
Weston, OH 43569
(800) 367-2020

Sulfur cement
Martin Resources
P.O. Box 191
Kilgore, TX 75663
(800) 231-4595

White calcium aluminate cement
Aluminum Company of America
Alcoa Chemicals Division
P.O. Box 300
Bauxite, AR 72011
(800) 643-8771

Expansive admixture
CTS Cement Manufacturing Co.
11065 Knott Ave., Suite A
Cypress, CA 90630
(800) 929-3030

Latex polymers, bonding agents, sealers and surface treatments
Harris Specialty Chemicals, Inc.
(Thoro products)
Call for local dealer
(800) 327-1570

Air Products and Chemicals, Inc.
7201 Hamilton Boulevard
Allentown, PA 18195-1501
(800) 345-3148

VIP DIVISION
P.O. Box 1253
New Smyrna Beach, FL 32170
(800) 228-5537

Larsen Products, Corp.
8264 Preston Court
Jessup, MD 20794
(800) 633-6668

CHEMCENTRAL Chicago
(Rohm & Hass Acrylics)
7050 West 71st Street
P.O. Box 730
Bedford Park, IL 60638
(800) 788-5232

Carbon fibers (high modulus)
Amoco Performance Products, Inc.
4500 McGinnis Ferry Road
Alpharetta, GA 30005-3914
(800) 222-2448

Carbon fibers in plastic rods
Avia Sport
P.O. Box 1408
Hickory, NC 28603
(828) 345-6070

Aramid fibers
H.M. Royal
689 Pennington Avenue
Trenton, NJ 08601
(800) 257-9452

Polyvinyl alcohol (PVA) fibers
Kuraray America Inc.
30th Floor, Metlife Building
200 Park Avenue
New York, NY 10166-3098
(212) 986-2230

Polyethylene fibers
Allied Signal, Inc.
Polymers Division
P.O. Box 31
Petersburg, VA 23804
(800) 707-4555

Processed cellulose fibers
DPD, Inc.
2000 Turner Street
Lansing, MI 48906
(517) 485-9583

Various fibers
MiniFIBERS, Inc.
2923 Boones Creek Road
Johnson City, TN 37615
(423) 282-4242

Stainless steel wool, bronze wool
International Steel Wool Corp.
1805 Commerce Road
Springfield, OH 45501
(800) 543-6960

Global Material Technologies
2825 W. 31st Street
Chicago, IL 60623
(800) 621-8934

Stainless steel wire
American Wire Works, Inc.
3380 Tulip Street, P.O. Box 12740
Philadelphia, PA 19134
(215) 744-6600

Wire and Cable Specialties, Inc.
205 Carter Drive
West Chester, PA 19380
(800) 824-9473

Stainless steel wire cloth
Stainless Steel Woven
Fabric Cloth Co.
5601 W. Slauson Ave., Suite 260
Culver City, CA 90230
(310) 258-9125

INDEX